08: 04

MAKE YOUR MARK

Explore Your Creativity and Discover Your Inner Artist

By Margaret Peot

CHRONICLE BOOKS
SAN FRANCISCO

Library of Congress Cataloging-in-Publication
Data available.

ISBN: 0-8118-3823-4

Manufactured in China

Distributed in Canada by Raincoast Books
9050 Shaughnessy Street
Vancouver, British Columbia V6P 6E5

10 9 8 7 6 5 4 3 2 1

Chronicle Books LLC
85 Second Street
San Francisco, California 94105

www.chroniclebooks.com

Designed by Fine Design Group

ACKNOWLEDGMENTS

A heartfelt thank you to Hans, Kathie, and Mark Peot, for their love and unflagging support.

Special thanks to my editor, Mikyla Bruder, for her amazing focus and clarity, and to the rest of the terrific editorial and design team at Chronicle, Leslie Davisson, Vanessa Dina, Tera Killip, and copy editor Carrie Bradley. Thank you to my brilliant, insightful agent, Susan Lescher, and to Ruth Teitel who introduced us. Thanks also to Myra Kornfeld, Glynnis Osher, and Linda Erman for their persistent enthusiasm and encouragement over the years. Thanks to Barbara Clark for her sterling, bountiful advice, and to Irene Levy-Roll for giving me the seed of the idea for this book. Thanks also to Ardis Macaulay, teacher, friend, and font of inspiration, and to Barbara Mauriello and Robert Warner for glue, glitter, tool tips, and lunch. Thanks to John Ragusa, a true artist with the color Xerox, to Isis Medina for keeping me well adjusted, and to David Aldera of New York Central for his paper wisdom.

Thanks also to Carolyn Larson, Mickey Choate, Angela Frye, Helen Holoviak, Monona Rossoll, Virginia Clow, Martha Walker, Emily Jones, Gretchen Hall, and Sally Ann Parsons.

FOR DANIEL & SAM

TABLE OF CONTENTS

INTRODUCTION

Have you ever sat before a blank sheet of white paper feeling apprehensive? Did you think of something else you needed to do, like pay the bills or sort through the kitchen catch-all drawer? For many of us, experienced artists and beginners alike, the most daunting part of any creative endeavor is making your first mark.

This book contains ideas and exercises that will help you get past the fear of making your mark. Included in these pages are step-by-step instructions for a variety of creative mark-making techniques, plus innovative exercises that will help you get something going on that white piece of paper and get your creative juices flowing.

The exercises in this book require no special artistic skill to complete. For the beginning artist, experimenting with techniques can aid the development of visual skills and confidence, and help to launch you on your creative path. For the experienced artist, they can be useful tools for helping you further your current work, begin a new piece, or break through an artist's block. Whichever category you belong to, you cannot help but have some productive experiences with the techniques explained herein.

Before you begin with the exercises, read the section called "Getting Started," which details everything you need to know to begin making the first mark. From tips for setting up a work space to a discussion of important materials and equipment to safety information, this section will help you confidently turn to the exercises and work safely, efficiently, and without interruption.

Much like a cookbook, the technique chapters offer ingredients lists and step-by-step instructions for making marks using a variety of tools and methods. Some chapters, like the stencils and prints chapters, teach somewhat complex techniques and offer quite a few exercises and variations. Others are much more brief, like the rubbings and paste papers chapters, which teach very simple techniques that you can use again and again for very different effects. From water prints to the art of resist, invisible ink to pattern dyeing, you'll find many procedures to choose from. Begin at the beginning, or flip through the pages until you find something that catches your eye. The exercises within each chapter are designed to build upon one another, but you needn't learn the techniques themselves in any specific order.

top
Marbling on paper, india ink combined with a photographic wetting agent, swirled with a wooden skewer, Chapter 7

bottom left
Wheat paste and acrylic paint on paper, pattern made by twisting the rim of a plastic cup in the paste mixture, Chapter 8

bottom right
Acrylic gloss and gel mediums and black acrylic paint, india ink, Chapter 5

Each of the first eleven technique chapters includes illustrations and exercises, as well as questions to help you reflect on the completed exercises. The purpose of the exercises is not necessarily to create individual art works; although you will surely create some beautiful pieces, the point is to get you to make some evocative marks that will act as springboards for creative thought. The exercises in *Make Your Mark* are intended to loosen you up, to have you making unselfconscious marks right away. From those unselfconscious marks, the seeds of art making are sown.

The last chapter in this book is titled "Making Your Next Mark." After learning the techniques in the book, you may ask yourself: What do I do now? This chapter addresses that concern with a questionnaire to help you zero in on what you might want to do with what you have learned. Also included are some ideas and suggestions for projects and applications for the techniques you have learned in the preceding chapters. A few parting notes on drawing may help you stay loose and avoid old habits. "Making Your Next Mark" encourages you to start building on the techniques you have learned, and to express something personal and meaningful to you.

Lastly, you'll find three practical sections at the back of the book: a list of suppliers, a selection of stencils patterns, and a glossary of terms. The Suppliers section, with names of vendors and contact information, will help you find the materials used in this book. The Stencil Patterns pages provide a number of simple drawings for you to trace around and use for the various experiments. I highly encourage you to use these (think of them as training wheels on a bike) so that you can do the exercises and try the different techniques without getting hung up on drawing something. The glossary provides definitions of terms you may not be familiar with.

While doing these exercises, you will make some beautiful marks. You will also make some ugly ones. Good! Don't panic: You are doing all the right things. You will learn, have some fun, get inspired, and soon you will be fearlessly making countless marks, pursuing your creative vision.

Scale stencil, Chapter 1

Acrylic gel medium resist, Chapter 5

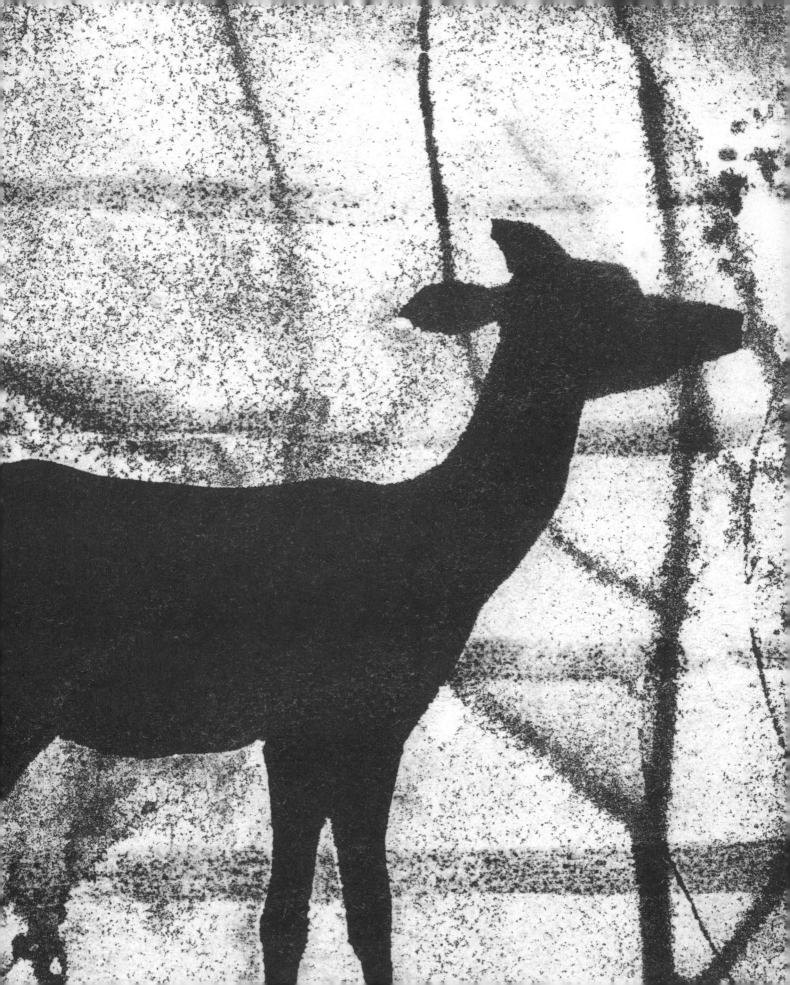

GETTING STARTED

There are a few fundamental things you'll need to do before you begin the exercises in this book. If you don't already have a dedicated work space, I recommend you take a little time to set one up; see below for more information. Then you'll need to stock up on basic materials, including good paper, and some useful equipment and simple safety gear.

SPACE TO WORK

The first step in making the first mark is making a work space. This is a way of honoring your creativity and giving it space to grow. Your work space doesn't have to be elaborate, but it needs to be a place that you don't have to clean up before dinner. If your dining room table is your work space and also the place where you eat your meals, where the mail gets stacked, or where your children do their homework, it isn't a good place for you to do your creative work.

The ideal place to work is behind a closed door. If you don't have a room with a door that closes available to work in, but instead have a corner designated, look around and see if there is any way to make it more private, perhaps using screens or curtains. You will want to try some daring things in your new studio space: You *must* try some daring things. No one but you will try the audacious things that are in *your* mind—and it is actually easier to try new things if you don't have your loving friends and family coming up behind you and saying encouraging things about your experiments.

The foundation of a good work space is a large, sturdy table, or other work surface. A hollow-core door set up waist-high on supports works well, giving you the option to stand up while you work and making a chair unnecessary. It is also desirable to have a place to tack up things to look at; a cork board is good for this. Tack up pictures and postcards you like, as well as the results of the experiments from this book as you work on them. Writer Anne Lamott stretches a clothesline across her studio space and uses it as a place to hang pages of writing to look at and think about and rearrange. You could use a clothesline in the same manner to hang your work from this book.

You will also need light. A window doesn't always provide the best light: There is nothing more distracting than a big beam of sunlight shafting across your work. Try a couple of inexpensive clip-on lights—one focused on your work space and one on the place where you hang finished work.

To protect the work surface and surrounding areas, purchase a medium-weight plastic drop cloth from your local hardware or paint store. The drop cloth will be much larger than you actually need, so cut it down to a size slightly bigger than your work surface and save the rest for future use. Line the floor around your work surface with newspaper to make a place for your experiments to dry.

It is nice to have dedicated shelves and drawers for storing your supplies, but if that's not possible, the floor space under your table will do. You will also want to have a garbage container conveniently placed. A garbage can would be great, but a plastic grocery bag push-pinned into the side of your table works fine, too. In other words, don't wait for your work space to be perfect before you declare it ready for action.

PAPER

Invest in good paper: Your marks will look much better on high-quality art paper. Don't use cheap newsprint or construction paper, which are not acid free and will yellow and decay after a short time. The techniques in this book often call for wiping and rubbing and getting paper very wet, sometimes even submerging it in water, so buy a heavyweight cotton paper, like Rives BFK. This paper is appropriate for nearly all of the exercises in the book (when it isn't, the exercise will specify which type to buy). Rives is readily available in art supply stores, as it is popular with many artists for its versatility and strength. It comes in white, bone, cream, and gray. Avoid colors for now. Get the white to start with—it is a beautiful warm white, suited to many

applications. There are numerous other good papers on the market. When an ingredients list calls for medium to heavyweight white or cream-colored paper, you can feel safe purchasing any of the following brands: Rives BFK, Lenox, Stonehenge, Somerset, Arches Heavyweight, or Rives Lightweight. Lenox and Stonehenge come in bigger sheets and are cheaper than Rives. Select a few different kinds of paper to try, and find out which one works best for you.

Get plenty of paper. For almost every exercise in this book, you will also be doing suggested variations, and these in turn will inspire you to try variations of your own. Some standard sheet sizes for art paper are 18 by 24 inches, 22 by 30 inches, and 30 by 44 inches. Buy larger sheets of paper, in the 22-by-30-inch range, and tear them into smaller pieces (more on tearing below). Try not to worry about cost. A 22-by-30-inch sheet of Rives BFK might cost as much as a few dollars. But this sheet can tear down to as many as nine smaller sheets. If you buy three large sheets, you have purchased hours of fun and learning for less than the cost of taking yourself to the movies. Some stores will offer a discount if you buy multiple sheets, so be sure to ask if you're considering buying a number of pieces.

When you're using art paper with a deckled edge, it's better to tear the paper to size rather than cut it with a straightedge. There are two reliable methods for tearing paper. One is to use a tool called a bone folder, available in art supply stores that carry bookbinding supplies. Bone folders are small, flat, picket- or ruler-shaped tools about an inch wide and of various lengths; the classic length is 6 inches. Made of plastic or genuine bone with one

edge slightly sharper than the other, it is used to make exact creases when folding paper. To tear your paper, fold it as you like and rub along the crease with the bone folder to press it flat from the outside. Then slip the bone folder flat into the fold with the sharper edge facing in (if necessary, you can sharpen the edge further with a piece of fine sandpaper). Cut along the crease in one smooth motion. The act of creasing weakens the paper slightly and the bone folder will separate the paper into two pieces easily. The second method is to lay a metal straightedge or ruler along the line on the paper that you wish to tear and pull the paper up and across to tear against the metal edge. You don't need to draw the entire line that you are going to tear; just make two tiny pencil marks on the opposite edges of the paper as a guide for your straightedge. Be sure to hold the straightedge very securely while you pull the paper to prevent it from slipping.

PREVAL SPRAY GUN

Quite a few exercises in this book call for a Preval spray gun. This pocket-sized paint sprayer consists of a glass bottle to hold the paint and a small canister of compressed air that screws onto that. The Preval is relatively inexpensive and readily available at art supply stores and better house paint stores that carry decorative painting tools. You can substitute a standard pump sprayer, plant mister, or a traditional metal atomizer (as used to spray non-aerosol fixative on pastels, sometimes called a spray diffuser). Both the Preval and atomizer produce a fine spray that shows off the details of the found objects, while the pump sprayer produces a dramatic, very coarse spray. If you have access to an airbrush and compressor, you can certainly use that as well.

Using a Preval spray gun takes a little practice. Before attempting to paint, fill the bottle with water and spray on a piece of cardboard to practice getting an even spray. Follow the manufacturer's instructions for the best results. In addition to those instructions, review the following tips:

- To ensure an even spray, press the spray button straight down. It is sometimes easier to do this if you hold the sprayer in your fist and press the button with your thumb rather than your forefinger.
- Do not shake the paint bottle while the sprayer is attached.
- If the spray button isn't working properly, soaking it in denatured alcohol will soften the paint trapped in the nozzle. After soaking, thoroughly flush the sprayer by spraying warm water through the nozzle.
- If you have purchased more than one spray gun, you may find that you have favorite spray buttons that make a great, even spray; detach these and use them on subsequent spray guns that you buy.

PREPARING PAINT FOR USE
IN A PREVAL SPRAY GUN

For the recipes in this book using a spray gun, you will employ paint of different varieties, from liquid or medium-viscosity black acrylic paint to gouache. To prepare any of these paints for use in a sprayer, you simply need to thin it with water to the consistency of dairy half-and-half. For liquid acrylics, that means about two parts water to one part paint. For gouache and medium-viscosity acrylics, a good place to start is three parts water to one part paint. (The viscosities of paints vary widely between brands and types, so the proportion of water to paint will vary.) Many paints mix easily right in the bottle attachment; for thicker paints, a better option is to mix it in another container first and then funnel it into the bottle. To prevent your sprayer from getting clogged, you may want to strain the paint through a double thickness of cheesecloth while funneling it into the bottle.

WHAT DO YOU SEE?

This question is asked a lot throughout this book, as a way to get you to stop and look at your completed exercises and think about them. There is no right answer to this question! Don't expect everything to please you, or to look like anything at first. It is important for you as an artist to get in touch with your own internal sense of right and wrong and to develop your personal aesthetic.

NOTES ON SAFETY

You will be using a wide variety of art materials in this book, all of them with particular properties that require some simple safety gear. Part of being an artist is being responsible for your own safety, and using materials wisely and safely is the hallmark of an experienced artist. Pay attention to the warning labels on the materials you use.

• Use protective gloves with all art materials: watercolors, india ink, acrylics, gouache, and oil-based paints and inks. You can use the yellow dishwashing gloves found at most grocery stores, or if you prefer a thinner glove, try latex examination gloves from a drugstore, pharmacy, or surgical supply store. If your skin is sensitive to latex, try latex-free nitrile exam gloves, available through the Lab Safety catalog (see Suppliers).

• Use a respirator mask with replaceable filter cartridges when you are spraying something or when you are using an oil-based ink and its solvents. Anytime you spray paint, you should wear a respirator with the appropriate cartridges for paint mists. Respirators are available at hardware and paint stores. Read and follow all manufacturer's instructions as to safe use. I also recommend you ask your healthcare provider where you can go to get medically certified to use a respirator. Sometimes safety programs like this are offered at your local hospital. Then you will know what size respirator to buy and what cartridges you'll need for the task at hand. In addition to the respirator, anytime you spray or use solvents, you should be in an adequately ventilated space, with a good window-venting fan.

• Do not use art materials around children unless they are specifically designated on the container as nontoxic and safe for use with children.

A WORD ON COLOR

The exercises in this book call for a very limited color palette. There are three reasons for this. The first is that it is simpler to start with black and white rather than getting stuck trying to pick a color to use. You need to get started and have fun, with as few stumbling blocks as possible. The second reason for using a limited palette is the cost of materials. Several different media will be introduced for you to try—gouache, ink, acrylic—and the cost of buying even a partial palette for each medium might be prohibitive. The third reason is that this limited palette lends itself to being "drawn into" later with colored pencils, as discussed in the "Making Your Next Mark" chapter. The black and grays allow you to see more; for example, in the stencils chapter, the oatmeal used as a stencil could look like falling snow or cherry blossoms or a field of small flowers, but not if you have chosen red as the color to use with the oatmeal stencil initially. This book will give you confidence in your mark-making skills, and you can learn about and enjoy experimenting with color later.

Let's get started. Take a deep breath and stay loose!

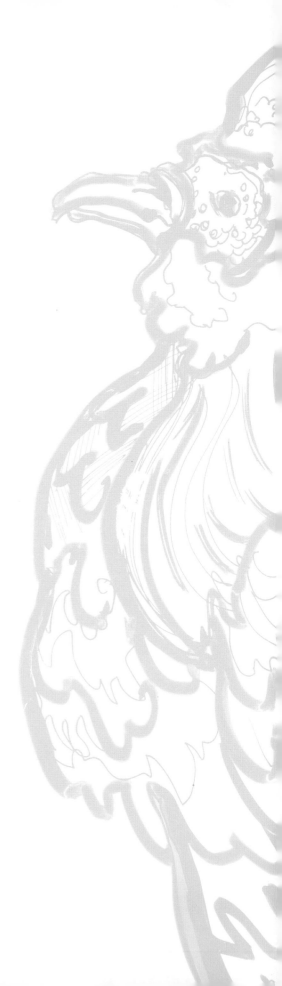

A STORY ABOUT "WASTE"

A man went to an old Chinese painter to commission a painting of a rooster. The painter named his fee, a respectably high number, and sent the man away for a month. At the end of that time, the painting would be finished. The man returned at the appointed time, four weeks later. The old artist took out a sheet of paper, a bottle of ink, and a brush and proceeded to make a glorious painting of a rooster: a bird with a jaunty pose, a twinkle in his eye, elegant plumage, and a wonderful attitude. It took the old painter all of five minutes to paint it. He turned to the man for payment. The man protested: It hadn't taken any time to do. Why should he pay such a high fee? And why did he have to wait a month to have a painting that took five minutes to paint? The old artist opened the door to his studio. Inside were hundreds of ink studies for the rooster painting.

Where would that artist have been if he had been worried about supplies? Using paper for drawing is not wasteful. If you are enjoying yourself, learning something, and getting inspired, there is no waste.

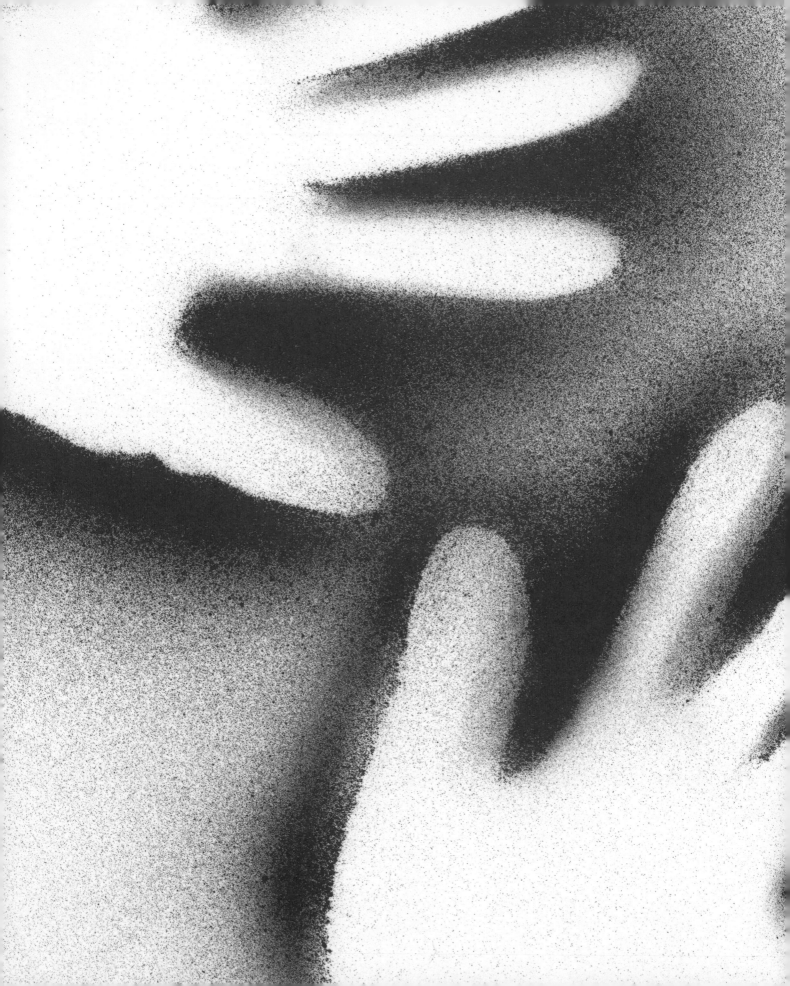

CHAPTER 1
STENCILS

Deep in a cavern in France, about thirty thousand years ago, prehistoric man used the stencil technique. By the wan light of a tallow lamp, he blew ground pigments mixed with water through a hollow reed at a stencil: his own hand. When he lifted his hand from the cave wall, he saw an image of his hand, pale against the stone, defined by the dark paint sprayed around it. That early artist used a stencil to capture a powerful picture of real life.

Anything can be a stencil. A stencil is simply something that blocks paint from your painting surface. For example, if you lay a nickel on a piece of paper and spray paint at the paper, what do you see when you pick up the nickel? What would happen if you put dried oak leaves on paper and sprayed across them? In the case of a hand or a nickel, a stencil leaves a simple silhouette; a feather or rumpled piece of net makes an almost photographically detailed image.

In this chapter, you will find exercises that call for natural materials such as dried flowers or grasses, as well as other found objects, for use as stencils. You can explore the use of lace, net, and oatmeal to make textural marks. You can also manufacture your own stencils, from torn paper for making painterly edges to Mylar cutouts that bring specific imagery of your own devising into focus. You will use these techniques throughout much of this book and as springboards for other projects. As prehistoric man discovered, stencils are a wonderfully direct way to make the first mark.

opposite
Sprayed acrylic-paint-and-water mixture, (gloved) hands as stencil

FOUND-OBJECT STENCILS

What objects around you might make great stencils? The leaves of a house-plant, strands of fettucini, a handful of nuts and bolts—if you sprayed paint through any one of these things onto a piece of paper, or painted around it with a brush or sponge, what would you see? An object needn't be interesting in and of itself to make a great stencil; it simply needs to have an interesting shape. The images on the facing page were created using stencils such as geranium cuttings, wooden skewers, and safety pins. Old keys, leaves, dried flowers, branches, chains, ribbons, string, washers, and screws all make great stencils. Remember that the found objects you use as stencils are going to get paint on them, so don't use anything too precious.

YOU WILL NEED:
protective gloves
respirator
found objects
3 sheets medium to heavyweight white or
 cream-colored paper, torn into rectangles
 approximately 7 by 10 inches
masking tape (optional)
Preval spray gun filled with prepared liquid or
 medium-viscosity black acrylic paint
 (see page 8)

Put on the gloves and respirator. Choose a found object and place it on a rectangle of paper. If your object is lightweight, like a leaf, use a small piece of masking tape rolled sticky-side out into a cylinder to secure it to the paper. Using the spray gun, spray paint lightly and evenly across the paper and the found object.

Lift the stencil. Put it back down on the paper in a different place, perhaps just next to where it was before. Spray again. What has changed? Set the stencil and paper aside and let dry on newspaper. Try a few more found objects, this time arranging more than one on your paper. Spray again. What do you see when you remove the objects?

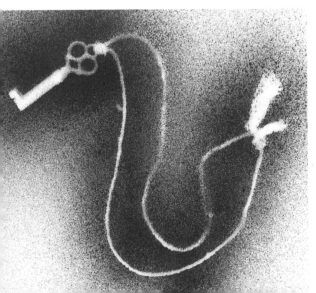

Sprayed acrylic-paint-and-water
mixture, key on string as stencil

Sprayed acrylic-paint-and-water mixture, wooden skewers as stencil

Sprayed acrylic-paint-and-water mixture, table fork as stencil

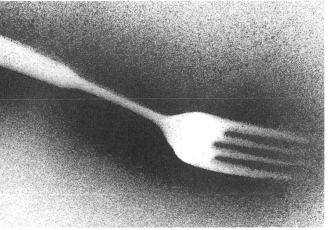

WHAT DO YOU SEE?

Gather your found objects around you on your work table. Often the objects you choose say something about you: where you live, where you have visited, what you like to do. You are going to use these things you found as stencils, and the resulting images may also say something about who you are. The gathering of these objects is the beginning of your creative work with them.

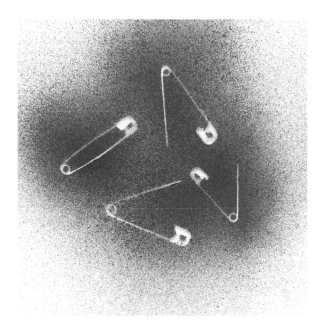

Sprayed acrylic-paint-and-water mixture, safety pins as stencils

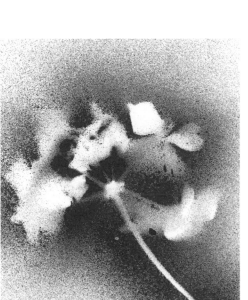

Sprayed acrylic-paint-and-water mixture, geranium cutting as stencil

FEATHERS

Look for feathers at millinery and bridal supply stores or craft stores. Ostrich and peacock feathers in particular make very dramatic stencils. You can also try goose feathers (stiff), coq feathers (small, curved), marabou (soft, fluffy), and others.

Place a feather on a rectangle of paper and secure it with a small piece of rolled up masking tape under the spine of the feather. Spray paint lightly and evenly across the paper and the feather. Lift the feather: What do you see? Try your other feathers.

To preserve the feather, soak it in a bucket of water after each use so the paint won't dry on it. When you're finished with the feather, rinse out the excess paint in the bucket, then use a little shampoo and warm water to wash out the rest of the paint. When you are satisfied that all of the paint is out of the feather, dip it into a container filled with about 1 quart water mixed with ¼ cup cornstarch and stir the feather around in the mixture. Pat the feather dry with paper towels, then dry with a blow dryer. Your feather will be almost as good as new.

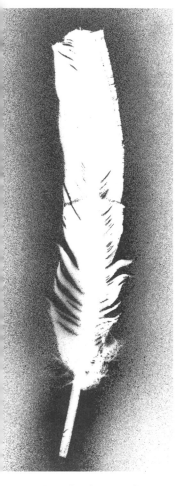

Sprayed acrylic-paint-and-water mixture, goose feather as stencil

TOOL TIP: MASKING TAPE

Buy a fresh, new-looking roll of masking tape. Sometimes the tape has been on the store shelf for a while; watch for telltale dirt or rolls that are malformed in some way. Old masking tape is problematic because the sticky stuff delaminates from the tape and can consequently be left on your artwork.

When you use masking tape on paper, it's not necessary to stick it down with much vigor. Gently lay it where you want it to be and very delicately tap it down along the edge you are going to cross with paint. Drafting tape, available at art supply stores, is less sticky and is easier to pull off paper without leaving a blemish.

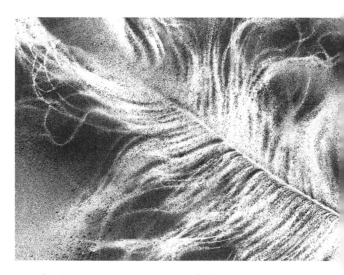

Sprayed acrylic-paint-and-water mixture, ostrich feather as stencil

NETS & LACE

Laces and nets make interesting stencils. The wrinkles in netting make strangely photographic marks, like rumpled fabric or undulating waves. Lace used as a stencil can give an ordinary piece of paper richness, evoking curtains in a window, for example, or the folds of a summer dress.

Cheesecloth netting is inexpensive and readily available at grocery stores; burlap and erosion cloth are available at hardware stores that sell to agricultural communities and also from theatrical suppliers. Hair nets, plastic net bags for oranges or potatoes, nylon sport nets, and bridal veil netting are also good candidates. Look for scraps of lace in different weights and patterns on remnant counters in fabric stores, or buy small pieces off the bolt of a couple different kinds. Happily, the cheaper the lace, the better image it makes—cheap lace is usually made of a non-natural fiber and is not dainty, so it makes a clearer mark. Try super-cheap lace tablecloths, curtains, or even paper doilies.

Place a piece of lace on a rectangle of paper. Spray paint across the paper and the lace. Spray more heavily in some places, more lightly in others. Lift the lace: What do you see? Crumple the lace and place it on another piece of paper. Spray paint through the crumpled lace onto the paper. Lift the lace. How is this different from the flat lace image? Wrinkle a piece of net or cheesecloth, place it on a piece of paper, and spray through it. Next try placing a piece of net in curtainlike folds on a piece of paper and spraying through that.

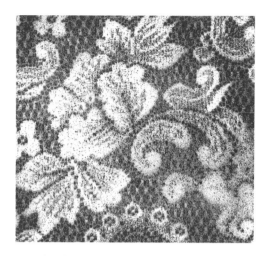

Sprayed acrylic-paint-and-water mixture, lace as stencil

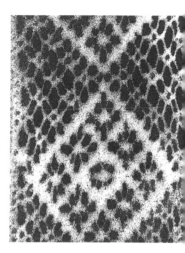

Sprayed acrylic-paint-and-water mixture, lace border as stencil

When you are ready to clean up, rinse the lace or net in a bucket of water, then wash it in a sink with warm water and laundry detergent. Hang to dry.

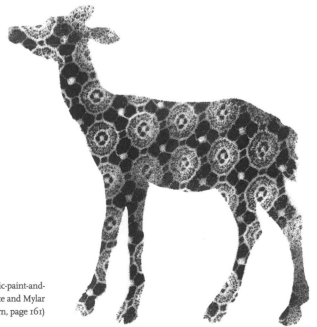

Sprayed acrylic-paint-and-water mixture, lace and Mylar deer stencil (pattern, page 161)

SCATTER STENCILS

Scattering a handful of small objects such as pebbles, grass clippings, oatmeal, seeds, or sawdust on a page and spraying across it creates evocative textures. Oatmeal can make a mark like petals or leaves falling. Sawdust can look like snowflakes tossed in the wind, or a granite surface.

YOU WILL NEED:
protective gloves
respirator
oatmeal or sawdust
1 sheet medium to heavyweight white or
 cream-colored paper, torn into rectangles
 approximately 7 by 10 inches
Preval spray gun filled with prepared liquid or
 medium-viscosity black acrylic paint
 (see page 8)

Put on the gloves and respirator. Sprinkle the oatmeal across a rectangle of paper so that some areas are thinly covered and others are thickly covered, and some places have no oatmeal at all. Using the spray gun, spray paint lightly and evenly across the paper and oatmeal. Shake the stencils off into a garbage container. What do you see? What does it make you think of? Repeat to make other stencils.

Sprayed acrylic-paint-and-water
mixture, scattered oatmeal as stencil

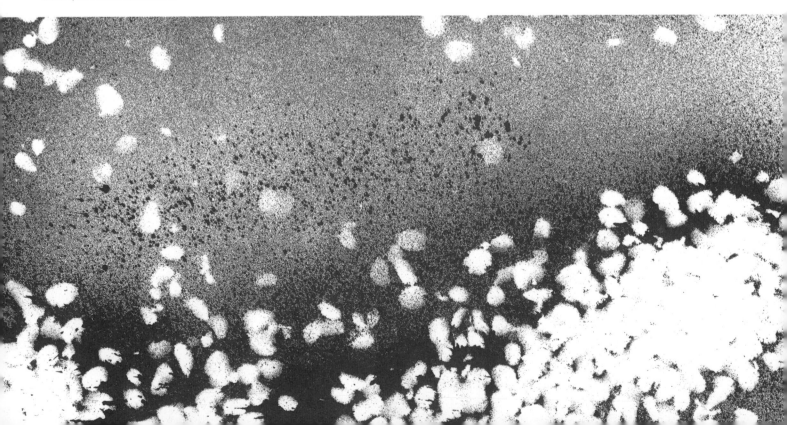

GRASS CLIPPINGS & OTHER SCATTER STENCILS

Sprinkle grass clippings or fresh chives on a piece of paper and spray paint lightly and evenly across the paper and the grass. Shake the stencils off into a garbage container. What do you see? Does the mark made look like grass, or something else? Repeat, using seeds, rice, pebbles, dried herbs, or petals.

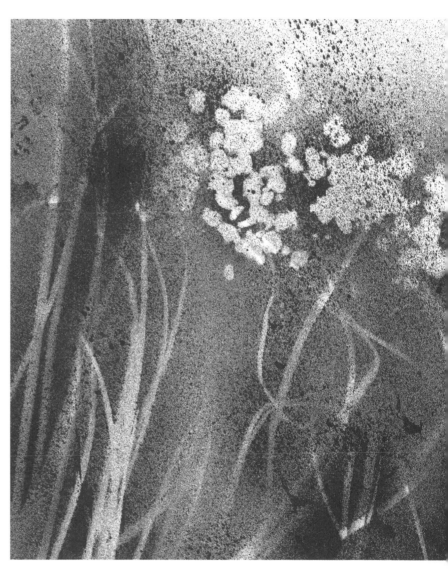

Sprayed acrylic-paint-and-water mixture, scattered oatmeal and chives as stencil

SUN-SENSITIVE PAPER

Sun-sensitive paper is coated with chemicals that respond to ultraviolet light by darkening into a rich cerulean color. This paper, available in art supply stores, provides an almost effortless means of making interesting marks on a page. It is as simple as placing a found object on a piece of the sun-sensitive paper, leaving the whole lot in the sun for 2 minutes, then setting the object aside and rinsing the paper in cool water. Any found object with an interesting silhouette will work: plants, shells, netting, lace, feathers, utensils, jewelry, arrangements of toothpicks, seeds, beans, rice, small toys, or crumpled tissue paper.

If you wish to make an elaborate setup of objects on sun-sensitive paper, attach the paper to a same-size or larger piece of cardboard with small pieces of masking tape rolled into cylinders with the sticky side out, and set up your arrangement out of the sunlight. You can also rearrange the objects in the middle of the exposure time for an interesting effect.

When you first remove your object or objects from the paper, you will see a faintly darker silhouette of the object. When you submerge the paper in the water, the image will reverse itself, leaving a white silhouette on a pale blue ground. The blue will darken as the paper dries. If you see no image at all when the paper dries, it means the paper was exposed to the sun either too long or not long enough.

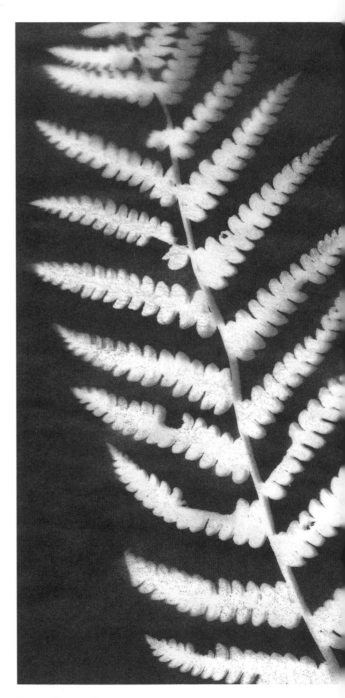

Sun-sensitive paper, fern

Sun-sensitive paper, slotted spoon

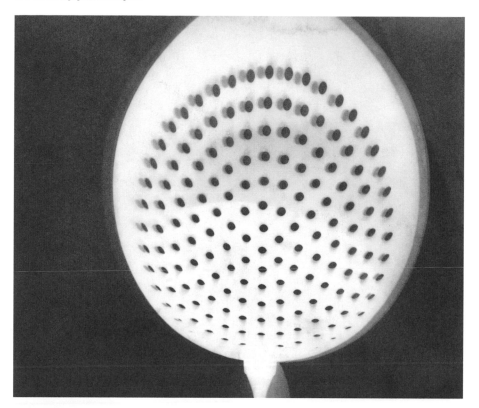

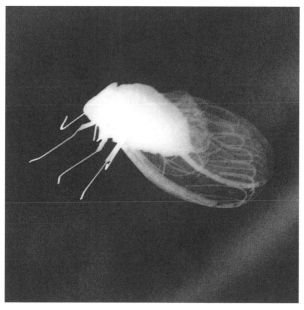

Sun-sensitive paper, toy bug

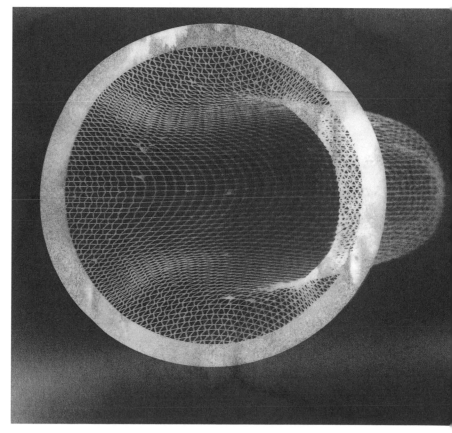

Sun-sensitive paper, sink strainer

TORN-PAPER STENCILS

Torn-paper stencils make a soft, painterly edge, very different from the sharp definition created by stencils with a cut edge. For example, you can conjure up a landscape using torn paper to make a distant horizon line of hills, a jagged tree line, and a grassy plain. In this exercise you will first spray the paint, then continue with paint applied with a chip brush and sponges to see what different marks these tools make.

Wooden-handled chip brushes are efficient, inexpensive, readily available brushes made for applying paste, glues, etc. Kraft paper is a coarse unbleached paper noted for its strength, most familiar to us in its grocery bag and packaging paper forms. You can buy it in rolls from New York Central Art Supply (see Suppliers, page 162). As it is used to wrap fine art papers at most art supply stores, the store clerks will sometimes give or sell you a piece from their roll.

Acrylic applied with a natural brush, torn paper as stencil

TOOL TIP: SPONGES

There are three different kinds of sponges: natural, cellulose, and foam. All three kinds make very distinctive marks. Natural sponge and cellulose sponges work best for painting, as they are more absorbent and hold more paint. Try tearing or cutting off the edges and corners of cellulose sponges, so the marks made by the sponges aren't so regular. A hardware or paint store will have the best selection of sponges. Air conditioner and other filter foams, foam for packaging, and insulating foams all have mark-making potential. Walk around the hardware or automotive supply store with mark-making in mind and see what interesting things you can find.

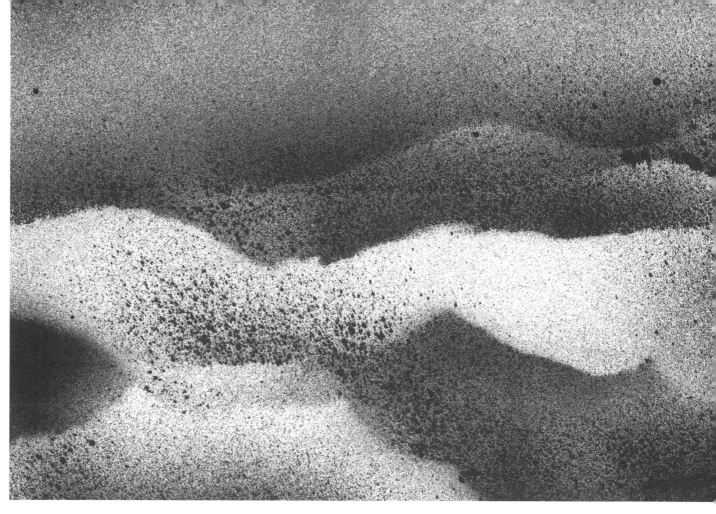

Sprayed acrylic-paint-and-water mixture, torn paper as stencil

continued

YOU WILL NEED:

protective gloves

respirator

kraft paper or a brown paper bag

1 sheet medium to heavyweight white or cream-colored paper, torn into rectangles approximately 7 by 10 inches

Preval spray gun filled with prepared liquid or medium-viscosity black acrylic paint (see page 8)

black acrylic paint (liquid or medium-viscosity, not thinned to spray)

clean, wide-mouthed plastic container with lid (a yogurt or cottage cheese container works well)

two 1- or 2-inch chip brushes

scissors

natural or cellulose sponge

masking tape (optional)

Put on the gloves and respirator. Tear off a piece of kraft paper and lay the torn edge horizontally across a rectangle of white paper. Using the spray gun, spray paint lightly and evenly along the edge of the kraft paper. Lift the stencil. Tear off another piece of kraft paper, creating a more jagged edge this time, and lay it across the same piece of white paper. Spray again. Lift the stencil. What do you see?

Put some paint in the plastic container. If necessary, mix a little water into the paint so that it is not stiff but also not runny and watery, approximately the consistency of yogurt.

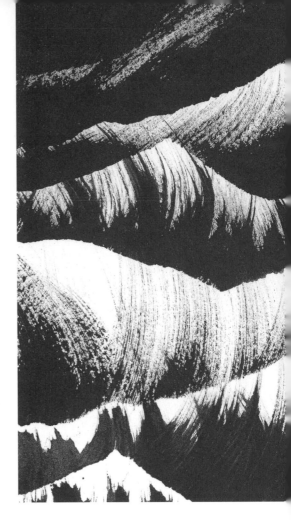

Tear off a piece of kraft paper and lay the torn edge horizontally across a rectangle of white paper, about two-thirds of the way down. Get some paint on a chip brush and wipe off the excess on the edge of the container. Starting on the stencil, paint off the edge, brushing away from the stencil so as not to push paint under it. Extend your brush marks 1 to 2 inches from the torn edge of the stencil. Try using a lot of paint, then try very little paint on a "dry" brush (one that has most of the paint wiped off). Lift the stencil. What do you see? Move the stencil down about an inch and over a little. Paint off the edge again, brushing lightly onto what you have just painted, but without obscuring it. Lift the stencil. How does that change what you see?

Using the scissors, cut into the other chip brush to make a jagged, pointy edge. Repeat the above steps on another rectangle of white paper using your altered brush. How does the new brush affect your mark?

To paint with the sponge, pour a little paint onto the lid of the plastic container. Tear off a piece of kraft paper and lay the torn edge horizontally across a rectangle of white paper. Hold the stencil in place with your hand or use small pieces of masking tape rolled sticky-side out into cylinders to secure it to the paper. Dip the sponge into the paint and blot off the excess on a piece of scrap paper. Sponge across the stencil, changing the orientation of the sponge slightly every time you put it on the paper to make a mark to avoid making a repeat pattern. Try sponging more in some places and less in others. Lift the stencil. What do you see? How is this different from the sprayed or brushed marks?

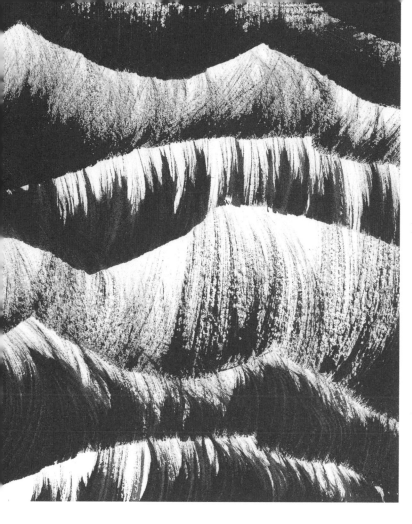

Acrylic applied with a brush,
torn paper as stencil

Acrylic applied with a dry brush, torn paper as stencil

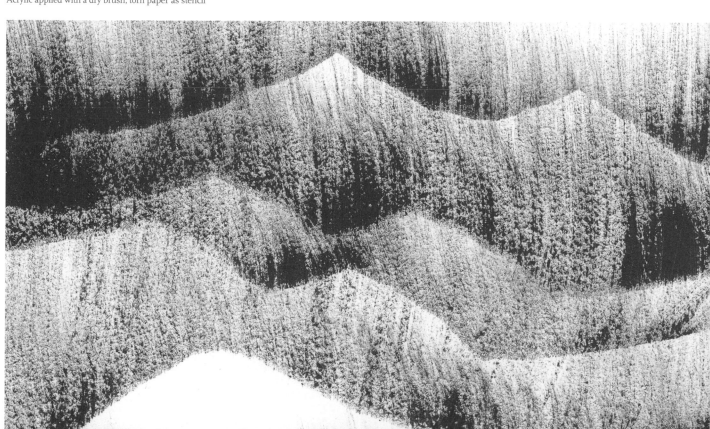

CUTOUT STENCILS

Precut stencils are available in a wide variety of shapes and sizes as well as decorative borders, patterns, and motifs in better paint stores and art supply stores, but sometimes you still can't find the image that you want. This is when you need to know how to make your own stencils. If you don't feel confident drawing at first, you can use the images in the back of this book, or you can use the copyright-free designs found in books like those published by Dover Publications. You can design extremely complicated stencils from ornate visual references, but keep in mind that you have to cut all the details yourself, and there's no guarantee that even a perfectly cut complicated stencil will be more effective than a simple one.

By cutting your own custom Mylar stencils, you can build a library of long-lasting stencils that can be used time and again. As you hone your stencil-making skills and your individual aesthetic develops, you can create stencil images that are more and more distinctly personal to you.

For this exercise you will create a vine stencil from the pattern in the back of this book. The goal here is to get you started on making and using cutout stencils without worrying yet about making your own stencil drawing. After experimenting with this stencil image, making and cutting your own stencils will make more sense.

Self-healing cutting mats protect your work surface and your knife blades. The special surface and core work together to return to smoothness after cutting. They are not indestructible, however, so vary where you cut on your mat; if you always cut in the same location, that spot will wear out.

one 18-by-24-inch piece .004 ml matte Mylar, or clear acetate

vine pattern (enlarged per the instructions on page 160)

pencil (or ballpoint pen if you are using clear acetate)

self-healing cutting mat or smooth cardboard

X-acto knife with no. 11 blades

paper towels

protective gloves

respirator

2 sheets medium to heavyweight white or cream-colored paper, torn into rectangles approximately 7 by 10 inches

Preval spray gun filled with prepared liquid or medium-viscosity black acrylic paint (see page 8)

masking tape

continued

Sprayed acrylic-paint-and-water mixture, vine stencil

Place the matte Mylar over the vine pattern and trace around the pattern with the pencil. Put the Mylar tracing on the self-healing mat and use the X-acto knife to cut along the lines. Save both the border around the vine and the vine itself. (In the following, the two stencils will be called the "vine border stencil" and the "vine stencil" to differentiate them.)

Make a stack of 4 or 5 paper towels beside you on your work surface.

Put on the gloves and respirator. Place the vine stencil on a rectangle of paper. Using the spray gun, spray paint lightly and evenly around the edges of the stencil. Lift the stencil and place it on another part of the same paper. Spray lightly around the vine stencil again. What do you see? To prevent excess paint on the stencil from dripping onto your work, lift the stencil and place it upside down on the paper towels to remove the wet paint. It doesn't have to be totally clean and dry; just dab off the drips so you can use it again. Place the vine stencil on the same piece of paper in a different place and spray again.

Dry the vine stencil on a clean paper towel. On another rectangle of paper, try placing and painting the vine stencil so the vine images radiate from a central point; or, place it and paint it so all the vine images are vertical and overlap.

Now experiment with both stencils in combination. Secure the vine stencil onto a new rectangle with small pieces of masking tape rolled sticky-side out into cylinders. Place the vine border stencil on the paper as you like, but being sure to overlap the vine stencil slightly, and spray into the cutout area. Lift the vine border stencil, leaving the vine stencil taped to the paper. Repeat until you have a dense thicket of vines, drying your stencil as needed. Let the paper dry a little, then gently untape the vine stencil and lift it off of the paper. What do you see?

Try using a 1-inch chip brush or natural sponge to paint in or around your vine stencil. Combine these methods with the spray method on the same piece.

TOOL TIP: MATTE MYLAR

Matte (also called frosted) Mylar, available at art supply stores, is the best material to use for cutout stencils. The waxed or oiled stencil paper available in many art supply stores is usually opaque; matte Mylar is semitransparent, allowing you to trace the image you want to cut directly, instead of tracing your image and then transferring it to a piece of stencil paper before cutting. Matte Mylar also seems to stay fresh and flexible over time. You can use acetate, but it can be harder to cut, as it tends to be brittle and gets even more so with age.

CUTTING YOUR OWN STENCIL DESIGNS

With a little planning, any image you can think of can be translated into a cutout stencil: birds, fish, coral, waves, landscapes, faces, buildings, flora, and fauna.

When cutting stencils, in some cases you must leave "bridges" to hold the stencil together. For a simple silhouette such as the vine stencil or an egg shape, it's not necessary, but for more complex designs you will need to leave a number of connective tabs in the cutout. For example, if you want to make a stencil of the uppercase letter R, you must leave 1 or 2 bridges somewhere around the curved part of the R to hold in the center. Shown here are three different ways to cut a stencil of the letter R.

Try using the stencils you make in the same way you used the vine stencil. See what other ideas this gives you for your stencil library.

If you find yourself cutting a lot of stencils, then you cannot do without a stencil burner. A stencil burner is an electrical tool that looks a little like a soldering iron. It has a wooden handle and a copper tip that heats up to melt the Mylar. To use a stencil burner, tape your image to your work surface, put a piece of glass on top, then place a sheet of Mylar on the glass. Secure with tape. You are able to see your design through the Mylar and glass, which makes for easy cutting. You have to work slowly—if you go too fast you get a ragged, incomplete cut—but it's much easier on your hand than using an X-acto knife.

When using a stencil burner, you must wear a respirator and work in a well-ventilated space, preferably by a good, window-venting fan. The melted plastic gives off toxic fumes.

By using bridges, you can also describe some inner details in your stencil image. In the following bird illustration, see how the plain outline, or silhouette, is changed when some bridge details are added.

BORDERS & TEXTURES: THE SCALE STENCIL

Cutting the edge of a piece of Mylar with scissors into a repeated shape is an easy way to make a decorative border or complicated-looking texture quickly. When you paint off the edge of this stencil with a brush, you create what looks like a shadow underneath a row of white scales. Try painting a fish or a dragon, or cover a mermaid's tail with shadowed scales using this technique.

YOU WILL NEED:
scissors
one 4-by-4-inch piece .004 ml matte Mylar
black acrylic paint (liquid or medium viscosity, not thinned to spray)
clean, wide-mouthed plastic container with lid (a yogurt or cottage cheese container works well)
1 sheet medium to heavyweight white or cream-colored paper, torn into rectangles approximately 7 by 10 inches
1- or 2-inch chip brush

Using the scissors, cut a line of scale shapes along one edge of the Mylar, as shown.

Put some paint in the plastic container. If necessary, mix a little water into the paint so that it is not stiff but also not runny, approximately the consistency of yogurt.

Lay the scale edge of your stencil across a rectangle of white paper, near the bottom. Get some paint on the chip brush and wipe the excess off on the edge of the container. Starting on the stencil, paint off the edge, brushing away from the scales so as not to push paint under them. As you are creating a shadow, you don't have to apply very much paint, just a light brushing that extends no more than ¼ inch from the edge of the stencil. Move the stencil away one scale's depth, shift it over half the width of one scale, and paint lightly off the edge again. Repeat until you have an overall texture of scales. As you can see, the paint describes the shadow of the scale on the scale beneath it, and leaves a highlight on the edge of each scale. Repeat to make other samples, experimenting with different patterns.

You can use your scale stencil to create the image of a fish. Use masking tape to mask off the simple outline of a fish body. Cut different sizes of scales to use as you move across the body of the fish. Perhaps the scales get smaller toward the tail end.

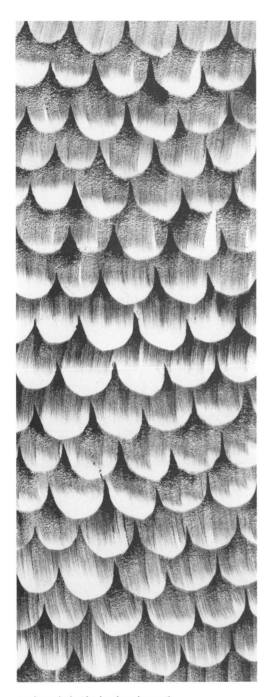

Acrylic applied with a brush, scale stencil

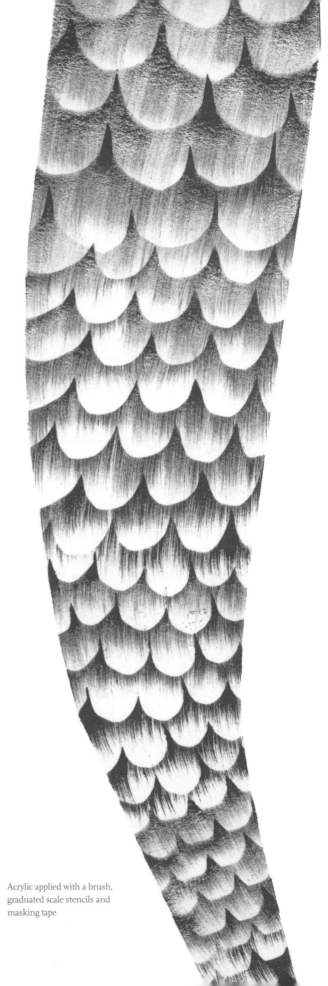

Acrylic applied with a brush,
graduated scale stencils and
masking tape

FUR, FEATHERS, & FAST CARS

This idea of a repeated and offset pattern is adaptable to many other textures as well. How could you use this technique to paint a bear's furry pelt? A feathered breast? Grass, waves, or clouds? A cityscape with lines of buildings? The flames on a fast car? What else? Here is an example of a stencil to paint a furry texture, as well as additional textures.

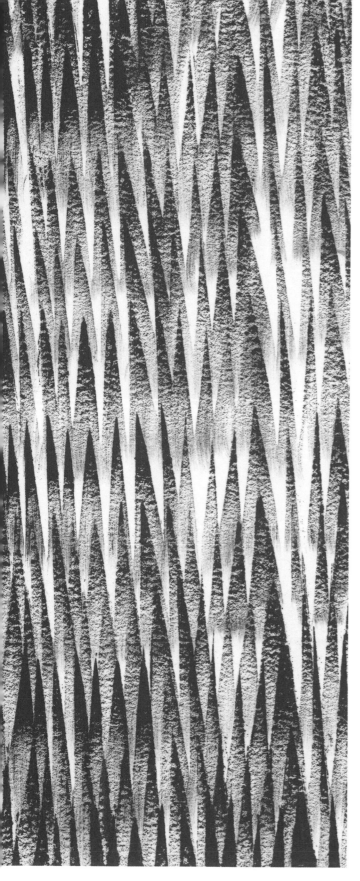

Acrylic applied with a brush, fur stencil

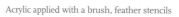

Acrylic applied with a brush, feather stencils

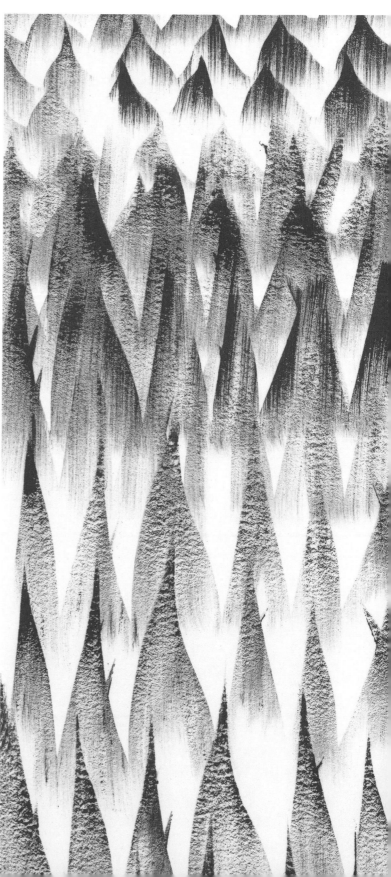

PRINTS

The earliest prints we know about were made in China, circa A.D. 800, by brushing water-based ink onto carved wood, then pressing paper onto the inked relief surface. Human beings must have a driving need to make printed images, as the first ones happened at about the same time paper was invented. Making prints was and is useful for making multiple copies of an image for communication or study—much easier than drawing the same thing over and over again.

You may already be familiar, at least by name, with some of the traditional techniques—wood cuts and engravings, linoleum cuts, etching, lithography and silk screening—employed by printmakers to make an endless array of image, tone, and texture. These printing methods are all drawing driven, as one commits marks to the printing block, plate, or stone with drawing tools such as gouges, etching needles, or wax crayons.

opposite
Square stamp, stamp pad ink

In this chapter, we'll explore relief printmaking using a variety of nondrawing techniques. You will find a variety of printmaking ideas, beginning with instructions for carving six simple stamps with which you can print complex geometric patterns. Then follows a number of techniques for manipulating foam rollers and rolling on paint to create intricate textures on the page. And finally, you'll find an array of exercises in which you will learn to print from plants, fruits and vegetables, even fish.

You will find that the processes of printmaking and the materials used are as diverse as they are satisfying. Nothing looks quite like a relief print: It has its own specific feeling and texture, and the results of printing from natural materials are often surprising.

SIX SIMPLE STAMPS

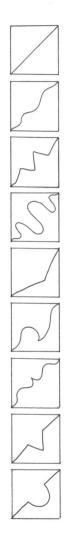

Cutting ideas for
stamp two

You have probably used rubber stamps before, choosing from the variety available in stationery and art supply stores. In this exercise, you will make your own stamps of simple graphic shapes and use them to print repeating designs. A repeat pattern can add a rich texture across a page, provide an architectural border for a free-flowing picture, enhance a journal page, or work as an interesting visual statement by itself. If you love this technique, you can buy eraserlike Soft-Kut blocks and a linoleum-cutting tool, and carve larger blocks with any graphic designs or specific imagery you choose. For this project, look for white vinyl erasers with sharp corners and edges.

YOU WILL NEED:
ruler
3 white vinyl rectangular erasers
X-acto knife with no. 11 blades
metal straightedge
pencil
3 to 4 sheets rice paper such as Mulberry or
 Kitakata, torn into rectangles approxi-
 mately 7 by 8 inches, or 20 sheets laser
 printer paper
black ink stamp pad

Measure the short side of an eraser, and use the measurement to mark off 2 squares on each eraser. Using the X-acto knife against the metal straightedge, cut the squares. If necessary, trim to make the squares uniform in size. Discard the trimmings.

STAMP ONE

Set one of the 6 eraser squares aside to use as is.

STAMP TWO

On the second eraser square, using the pencil, draw a diagonal line on the surface of the eraser from one corner to its opposite corner. It can be a straight line, a curving line, or a jagged line. Holding your X-acto knife perpendicular to your work surface, cut along the line down into the eraser, about one-third of the way through its thickness. Holding the knife blade parallel to your work surface and pointed away from you, and beginning about one-third of the way down the side of the eraser where the vertical cut ends, cut away half of your design like this:

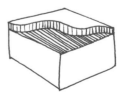

It isn't important if the new surface of the part you cut away is neatly cut or not, you just want it cut away enough so that when you press your stamp into the ink pad and onto the paper, the cut side won't pick up ink and make a mark on the page.

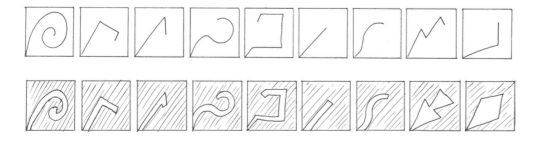

STAMP THREE

On the third eraser square, draw a bisecting line from the center of one side to the center of the opposite side. If you made a curving line for the previous stamp, try making a more jagged line for this one, or vice versa. As with the first stamp, cut vertically along the line with the X-acto knife through one-third of the eraser's thickness, then cut away half of your design horizontally about one-third of the way down where the vertical cut ends.

STAMP FOUR

For the fourth stamp, without hitting an edge, start at the bottom left corner and draw a simple line on the eraser square that ends somewhere in the middle of the square. Draw a line beside this one, slightly less than ¼ inch away, that ends at the end of the first line in the middle of the eraser. Cut along the lines, and carve away the negative space, as in this illustration:

Cutting away the part you don't want to print is a little harder than with the previous stamps, especially if you have to cut inside an enclosed area, but take your time and be careful with the X-acto blade. If you cut away a part you didn't want to, you can reattach it with white all-purpose glue.

continued

STAMP FIVE

For stamp number five, draw 2 perpendicular lines, so the eraser is divided into 4 equal squares. Cut down through one-third of the eraser's thickness along the lines. Make a horizontal cut to remove one square, then cut away the one diagonally across from it, to make a checkerboard pattern.

Stamp number five, the checkerboard stamp

STAMP SIX

Mark the last eraser square into 4 squares as you did above. Cut along the 2 lines all the way through. You will have 4 small squares. Choose 1 of the small squares and put the others aside. Draw 2 straight lines diagonally from corner to corner, crossing in the middle to make an X. Cut along both of these lines, about one-third of the way through the thickness of the eraser. Cut away 1 triangle, then cut away the triangle opposite it, as shown in the illustration.

Stamp number six, the small triangle stamp

These 6 simple stamps can now be used either by themselves to print interesting repeat designs, or combined to make wonderfully elaborate patterns.

Place a piece of rice paper on your work surface, ink your stamps, and play with different kinds of printing: Make random patterns, overlap the stamps, stagger the stamps like bricks, or print in concentric circles like paving stones in a piazza. Make borders and overall patterns. You don't have to re-ink the stamps every time you use them. You can make a rich value pattern by re-inking every third or fourth use, to make lighter and darker squares.

For another effect, on a clean piece of rice paper, use your pencil and ruler to mark off a light pencil grid with squares the same size as the eraser squares. Ink your stamps and stamp into the grid in any pattern you want.

Stamp number two, stamp pad ink

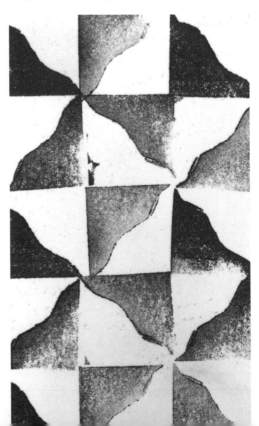

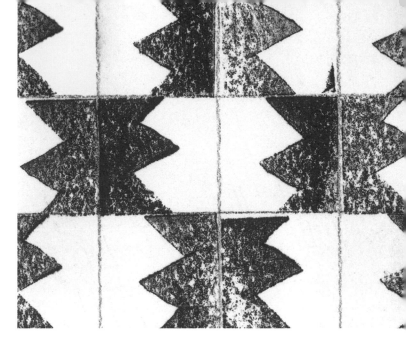

Stamp number three, stamp pad ink

Mix and match stamps, stamp pad ink on rice paper

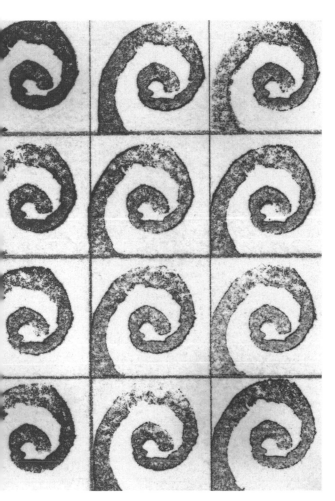

Stamp number four, stamp pad ink

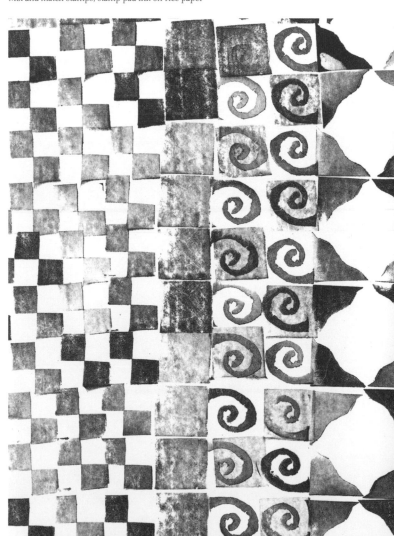

BASIC ROLLER PRINTS

In many paint stores that carry supplies for the decorative painter, you will find textural rollers for sale. Some are rubber rollers molded with a raised repeat pattern for making wallpaper-like painted patterns. Some have plastic wrap or fabric wrapped around them to make interesting rag-rolled textures. The next three projects all borrow these ideas for making beautiful layered marks on paper. In this exercise, knotted string, burlap, cheesecloth, and plastic wrap, wrapped and tied or sewn around a foam roller, are enlisted to make wonderful textures on paper. You can roll multiple times to build up an intricate surface. Use this technique to layer levels of texture in an artwork, make an aged-looking surface, or create the impression of foliage. Used in combination with stencils, this technique can produce exciting contrasts. When you're finished with one roller in this exercise, remove it from the handle and put it in a bucket of water to keep it from drying out. This makes for easier cleanup later.

Foam roller wrapped with raffia, large landscape stencil (pattern, page 161), acrylic on paper

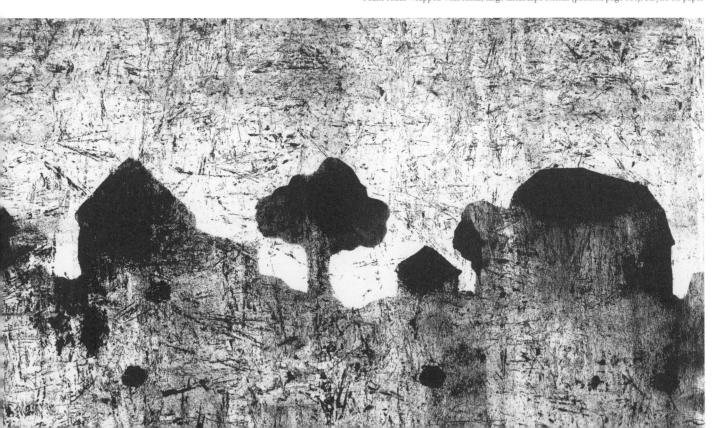

Foam roller wrapped with net, acrylic on paper

YOU WILL NEED:

string of different weights

five 4-inch foam rollers

burlap

needle and thread

cheesecloth

plastic wrap

protective gloves

black acrylic paint

plastic tray, approximately 10 by 10 inches,
 with a lid or plastic wrap to cover

spray bottle filled with water

roller handle to fit a 4-inch roller

1 sheet medium to heavyweight white or
 cream-colored paper, torn into rectangles
 approximately 7 by 10 inches

assorted Mylar stencils (see stencil patterns on
 pages 160–161, or create your own)

well-formed leaves from trees (any leaf will do,
 but oak leaves make good stencils, as they
 are often less brittle than other kinds)

Cut a piece of string about 15 inches long and
knot it securely at one end of a foam roller.
Wind it tightly along the length of the roller, so
that the foam is depressed in some places and
raised in others. Knot it securely at the oppo-
site end. You can cut the ends of the string off,
or trim them to about 2 inches long.

Tie several short lengths of string of varying
weights around another roller, leaving the
loose ends dangling from the knots.

Cut a 4-by-4-inch piece of burlap. Wrap the
burlap around the third roller, and stitch the
burlap to itself with the needle and thread to
secure it to the roller. Fray the edges of the
burlap if you wish. Repeat to wrap the remain-
ing two rollers in the cheesecloth and the
plastic wrap.

continued

Foam roller wrapped with knotted string, acrylic on paper

Put on the gloves. Put a tablespoon of paint in the plastic tray and spritz with water—you want the paint to stay juicy in the tray for this technique. You do not need to stir in the water as the roller will mix the paint and water when you roll it in the paint. (It is best to work with just a small amount of paint so the roller doesn't get clogged with paint and obscure your texture or pattern. Add more paint and spritz with water as you go.)

Choose a prepared roller and push it onto the roller handle. Roll it in the paint mixture to spread the paint out in the tray and get an even coat on the roller surface; this is called "loading" the roller. On a rectangle of paper, roll paint once from the bottom to the top of the page to see what pattern your roller makes. Roll multiple times, building up texture. What do you see?

On a clean piece of paper, hold a stencil in place with your hand, load a roller, and roll over the stencil, rolling more in some places and less in others to build up a texture.

As you roll over it multiple times, make sure you roll close to the stencil to define all of its edge detail. Lift the stencil. What do you see?

On another clean piece of paper, hold a leaf in place with your hand, load a roller, and roll over the leaf. Holding it by its stem, move the leaf to another part of the page and roll over it again. Do this several times on the same page to build up a leafy surface and a sense of foliage.

Continue to experiment with the various prepared rollers, combining them with different stencils as desired. What different textures do these materials make? Consider trying additional materials such as lace, tapestry fabric, or fringe. What else can you think of that might work with this technique?

Foam roller wrapped with net, oak leaves, acrylic on paper

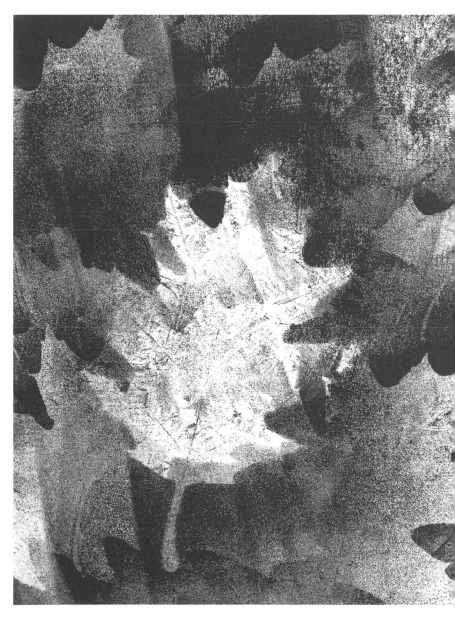

STORING YOUR ROLLERS

When you have loaded a new roller of your own design with paint for the first time, roll it once from the bottom to the top of an 8½-by-11-inch piece of high-cotton-content, acid-free stationery. Set the paper aside to dry, then store it with your clean roller. The rollers are durable and washable, and you will be able to use them over and over again. These one-roll samples are a great guide to the mark each roller makes, which isn't always apparent from the appearance of the roller itself.

TOOL TIP: FOAM ROLLERS

Buying foam rollers in bulk will save you money. Look for packs of 8 to 12 rollers, often called "contractor's packs," to save considerably on the price per piece.

CUTOUT ROLLER PRINTS

Using scissors to modify foam rollers creates a fun tool for making interesting repeat patterns on paper. A delicate pattern of teardrop shapes, a wandering vine, fish scales, and abstract shapes are just a few of the many options. Use these rollers to build up an interesting texture, or paint a Matisse-like wallpaper pattern.

YOU WILL NEED:
scissors
three 4-inch foam rollers
roller handle to fit a 4-inch roller
protective gloves
black acrylic paint
plastic tray, approximately 10 by 10 inches,
 with a lid or plastic wrap to cover
spray bottle filled with water
1 sheet medium to heavyweight white or
 cream-colored paper, torn into rectangles
 approximately 7 by 10 inches
masking tape (optional)
assorted Mylar stencils (optional; see stencil
 patterns on pages 160–161 or create your
 own)

Flatten the open blades of the scissors against the foam of a roller and close them, snipping off foam in the process. This will naturally make a teardrop cutout shape. Cut chunks out of the whole surface of the roller. You can run 2 or 3 teardrop cuts together to make larger chunks. Push the roller onto the roller handle.

Put on the gloves. Put a tablespoon of paint in the plastic tray and spritz with water—you want the paint to stay juicy in the tray for this technique. You do not need to stir in the water, as the roller will mix the paint and water when you roll it in the paint. (It is best to work with just a small amount of paint so the roller doesn't get clogged with paint and obscure your texture or pattern. Add more paint and spritz with water as you go.)

Cutout roller, acrylic on paper

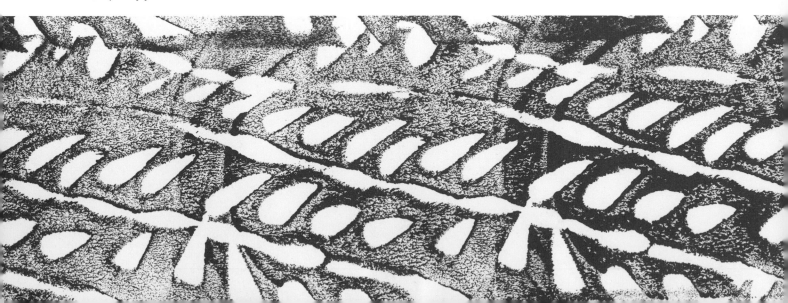

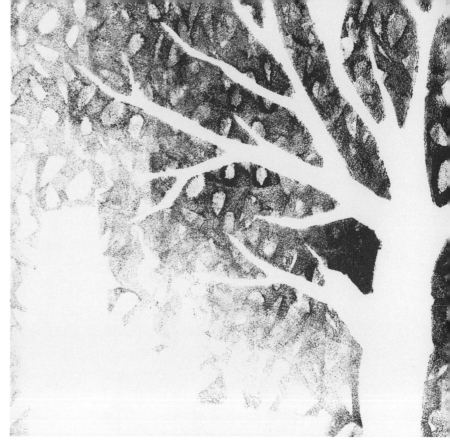

Cutout roller with tree stencil
(pattern, page 160), acrylic on paper

Roll the prepared roller in the paint mixture to spread the paint out in the tray and get an even coat on the roller surface; this is called "loading" the roller. On a rectangle of paper, roll paint once from the bottom to the top of the page to see what pattern your roller makes. Roll multiple times, building up texture. What do you see?

If you like, tape a stencil onto a clean piece of paper. Load the roller and roll over the stencil, rolling more in some places and less in others to build up a texture. As you roll over it multiple times, make sure you roll close to the stencil to define all its edge detail. You don't have to roll straight up and down. If your pattern looks like water or fish scales, a curvilinear roller path might be interesting. Remove the stencil and roll a bit, lightly, on the exposed white paper.

Cut the second roller with the scissors, this time making smaller cuts, or varying the direction of the cuts—making teardrop shapes oriented horizontally, vertically, or diagonally over the roller. What marks does this roller make?

Now make a repeat vine pattern. Use this same scissor technique—pressing the blades flat against the foam and cutting—to cut some long, thin pieces out of the third roller, winding around the roller like stripes on a candy cane. Then add "leaves" to these vines by cutting small teardrop shapes beside the lines. Play with this roller to find the most interesting marks the vine cutout will make.

Cutout roller with fish stencil (patterns, page 160), acrylic on paper

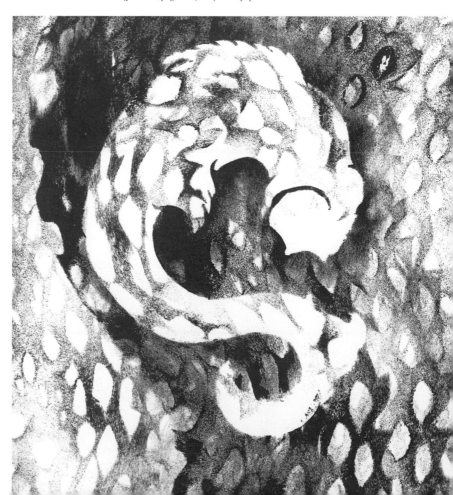

RAISED-PATTERN ROLLER PRINTS

In this exercise, you'll make raised patterns on foam rollers using silicone tile adhesive. The silicone is a quick-drying, rubbery substance that comes in a tube with a pointed tip perfect for drawing patterns. When you first roll, the raised silicone will make a black mark; then, as you press harder, the silicone will leave a white mark with dark edges around it. This is because the silicone is slick and impervious to paint, while the foam roller is absorbent. This makes for an interesting, changeable mark. Silicone tile adhesive is available at hardware and home-improvement stores.

YOU WILL NEED:

protective gloves

scissors

silicone tile adhesive

paper towels

two 4-inch foam rollers

2 chopsticks or paintbrushes with long, thin
 handles

black acrylic paint

plastic tray, approximately 10 by 10 inches,
 with a lid or plastic wrap to cover

spray bottle filled with water

roller handle to fit a 4-inch roller

1 sheet medium to heavyweight white or
 cream-colored paper, torn into rectangles
 approximately 7 by 10 inches

Put on the gloves. Using the scissors, cut just the tip of the adhesive tube off and squeeze to determine how big a bead of adhesive the hole yields. Cut again if necessary to get the desired size bead. (It is always easier to cut a bigger hole, but impossible to make the hole smaller, of course, so make small cuts.) Wipe scissors clean with a damp paper towel.

Slide a foam roller onto the end of a chopstick. Squeeze the adhesive onto the foam roller, holding the roller steady with your other hand, and make dots, circles, swirly lines, a random pattern, or a specific design. Secure the chopstick under a heavy book or block on your work table, with the foam roller sticking out off the edge. Repeat with the second roller, varying your design. Let dry for 30 to 60 minutes.

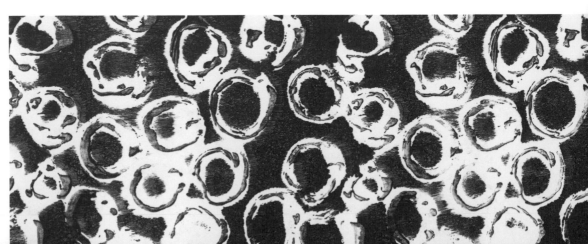

Raised silicone-tile-adhesive
pattern on foam roller,
acrylic on paper

Put a tablespoon of paint in the plastic tray and spritz with water—you want the paint to stay juicy in the tray for this technique. You do not need to stir in the water as the roller will mix the paint and water when you roll the roller in the paint. (It is best to work with just a small amount of paint so the roller doesn't get clogged with paint and obscure your texture or pattern. Add more paint and spritz with water as you go.)

Choose a roller and push it onto the roller handle. Roll it in the paint mixture to spread the paint out in the tray and get an even coat on the roller surface; this is called "loading" the roller. On a rectangle of paper, roll paint once from the bottom to the top of the page to see what pattern your roller makes. Roll multiple times, building up texture. What do you see? Play with both rollers to see the results of the different silicone shapes.

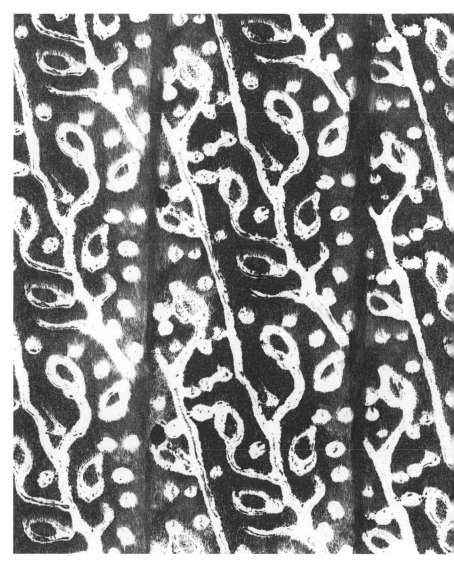

Raised silicone-tile-adhesive pattern on foam roller, acrylic on paper

PLANT PRINTS

Plants make extremely detailed, striking printed images. The ink seems to reveal more of the delicate tracery of leaf veins than you can see with the naked eye, making the prints look hyperreal. For hundreds of years, botanists, herbalists, and amateur naturalists have been making prints of natural materials for plant identification. In the days before the invention of photography, they would collect a plant, press it, and print it, roots and all, to record its appearance. These inked impressions would often be colored by hand to make a delicate, almost photographic representation of the plant. In this exercise and the following variations, you will learn how to prepare and use plant materials for printing.

YOU WILL NEED:
small plants (under 12 inches) pulled up by
 their roots, or cuttings from larger plants
telephone book
heavy books or a cinder block
3 sheets rice paper such as Kitakata, Okawara,
 or Mulberry
stack of newspaper or newsprint
protective gloves
respirator
black oil-based relief-printing ink
1 approximately 10-by-10-inch piece of glass or
 plastic, or a flat, wide plate that you don't
 ever intend to use for food
flexible metal 1- or 1 ½-inch-wide putty knife
4-inch rubber brayer
tweezers
paper towels

Your plant materials need to be in one general flat plane to print. You can coax them into flatness by pressing them. Plants with roots attached almost always need to be pressed before they're used for printing, whereas cuttings will sometimes lay flat enough without pressing. To press a plant or plant cutting, first wash excess dirt from the plant or plant roots and pat dry with paper towels. Lay your plant specimens between the pages of a telephone book and put the telephone book under a stack of heavy books or a cinder block. Leave them until you are ready to print, at least overnight.

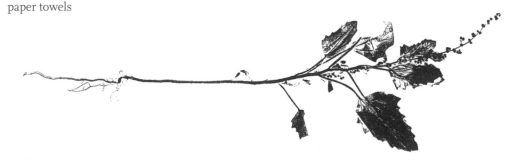

Printed plant,
oil-based ink on rice paper

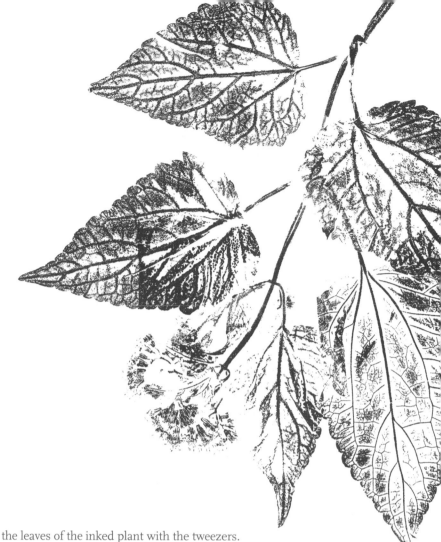

THE PRINTING STATION

Your printing station should have an empty space in the center of your work surface where you will make the actual prints. Your inking station (glass plate, ink, and stack of newspapers) should be on one side and your natural materials on the other side. Right-handed people may prefer to have their inking station on their right side, while left-handed people may prefer the left. See what works for you. Your paper, torn to size, should be above the printing area, and there should be a place on the floor covered with a drop cloth or newsprint to put your finished prints to dry.

READY YOUR PRINTING STATION (ABOVE).

Tear the rice paper into smaller pieces—the size of the pieces depends on the size of your natural materials. You will want to size them so that there is a generous margin around the natural object. Tear 2 or 3 pieces for every object you intend to print.

Place your pressed plant on top of the stack of newspaper. Put on the gloves and respirator. Place a small amount of ink on the piece of glass or plastic. Using the putty knife, smooth the ink into a flat bead. Roll the brayer in the ink until the roller is evenly, thinly coated. Working from the stem upwards and out-wards, carefully roll ink onto the plant. The sticky roller will pull up some of the leaves; unroll them gently before they tear off. Some leaves will just come off, and that's okay. Using the tweezers, pick the plant up off the newspaper and put it ink-side up on a paper towel in the empty space in the center of your printing station. You may want to rearrange

the leaves of the inked plant with the tweezers. Throw the inky newspaper away, leaving a fresh piece for the next inking.

Place a piece of the rice paper on top of the plant and gently rub the back of the paper with your fingers to make the print. (If your gloves are inky, you may wish to remove them for this step.) Try not to let the paper slip, as this will leave you with a blurry image. You will be able to feel the details of the plant through the paper, and this will help you to make a crisp picture. Lift the paper and set it aside print-side up to dry.

Without inking the plant again, put another piece of rice paper on it and again rub the plant through the paper. This pass will yield a more delicate impression, as there is less ink on the plant. Repeat to make more samples, using other plants or cuttings and varying how much ink you use to print.

Printed plant,
oil-based ink on rice paper

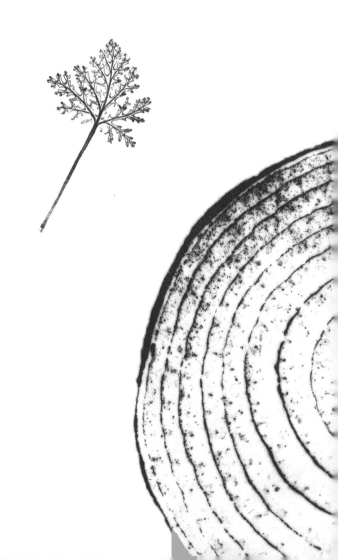

SEED PODS & DRIED LEAVES

center, top
Printed lemon slice,
oil-based ink on rice paper

right
Printed leaves
(gingko and geranium),
oil-based ink on rice paper

center, bottom
Printed onion slice,
oil-based ink on rice paper

opposite, center
Printed maple seedpods,
oil-based ink on rice paper

opposite, top right
Printed apple slice,
oil-based ink on rice paper

opposite, middle right
Printed seedpod,
oil-based ink on rice paper

Depending on where you live, finding greenery to print in the winter is something of a trick. You can always find leaves and seed pods to print, though, in any season. Choose leaves and pods that are somewhat flat and not curled up on themselves, as it is difficult to press dried winter leaves without cracking them. Look for oak leaves, gingko, maple leaves and seed pods, or catalpa seed pods. Print as described on pages 48–49.

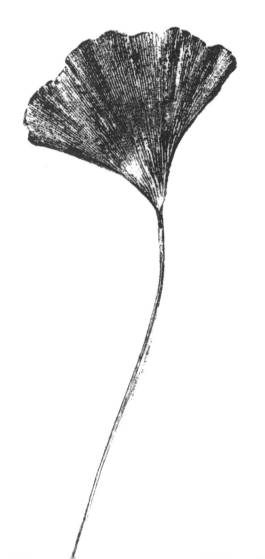

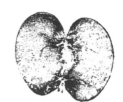

FEATHERS

You can use the same plant printing technique to print feathers. Sturdy feathers, such as the turkey feathers found in craft stores or songbird feathers you find on the ground, work best. Fluffier feathers like marabou or ostrich are not as suitable for this technique, although it can't hurt to try. Print as described on pages 48–49.

FRUIT & VEGETABLE SLICES

Slices of fruits and vegetables make beautiful prints. You can make small prints of individual slices, or print a number of slices arranged in a grid on one sheet, or print several slices placed haphazardly on a page for an unusual still life. Slice an apple or pear through the core, splitting the stem if possible. Slice an onion or a lemon crosswise to expose the pattern. The slices should be about ¼ inch thick. After slicing the fruits or vegetables, you will have to wait for a few hours for them to dry out slightly, so it is a good idea to slice them before you go to bed and print them the next day. Print as described on pages 48–49.

Printing multiple fruit or vegetable slices on one page takes a little planning. Tear a piece of rice paper to the size you want for your grid or still life, allowing for a generous margin all around, about 2 inches. Place this piece of paper on your work surface and tape off the perimeter, butting but not taping the edges of the paper. Set the paper aside. Ink the slices individually on newspaper and then arrange them ink-side up within the taped-off perimeter. Keep in mind that your actual print will be the mirror image of the arrangement of slices you are placing on your work surface. The oil-based ink is good for this project because it won't dry out while you are inking multiple slices—still, don't dally too much. Print as described on pages 48–49.

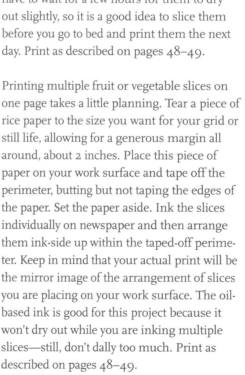

WORKING WITH OIL-BASED INK

When using oil-based ink, work in a well-ventilated space and wear a respirator (see page 9). Read and follow all manufacturer's safety instructions. Oil-based paints require denatured alcohol and kerosene for cleanup. Use these with extreme caution, as they are flammable. Read and follow all safety precautions on the label for these as well. All cleanup should be done wearing gloves. Use the putty knife to scrape down the glass or plastic on which you rolled ink, then wipe the knife on a piece of newspaper. Wipe down the glass or plastic with a paper towel soaked with denatured alcohol. Pour a small amount of kerosene onto a paper towel and roll the brayer across it. Repeat 3 or more times until most of the ink has been removed from the roller. Then, with a clean paper towel and a bit more kerosene, clean the roller well, including the handle. Clean the putty knife with the same paper towel. Wet all the dirty paper towels with water and put them in a plastic bag. Call your local fire department for instructions on how to dispose of these materials safely.

A SAFE CLEANING ALTERNATIVE

Instead of using solvents, you can also clean up with a vegetable oil such as safflower oil, and soap and water. This method takes longer than using solvents, but you may prefer it. Use the putty knife to scrape down the glass or plastic on which you rolled ink, then wipe the knife on a piece of newspaper. Pour a little vegetable oil on the glass and wipe the oil and ink with a paper towel. The oil will dissolve the ink slowly. Add a little more oil and wipe again. Pour more oil onto a clean paper towel and roll the brayer across it. Repeat 3 or more times until most of the ink has been removed from the roller. Then, with a clean paper towel and more oil, clean the roller well, including the handle. Clean the putty knife with the same paper towel. Wash the tools with mild soap and warm water to get off the oily residue. The oily paper towels can be disposed of in the garbage.

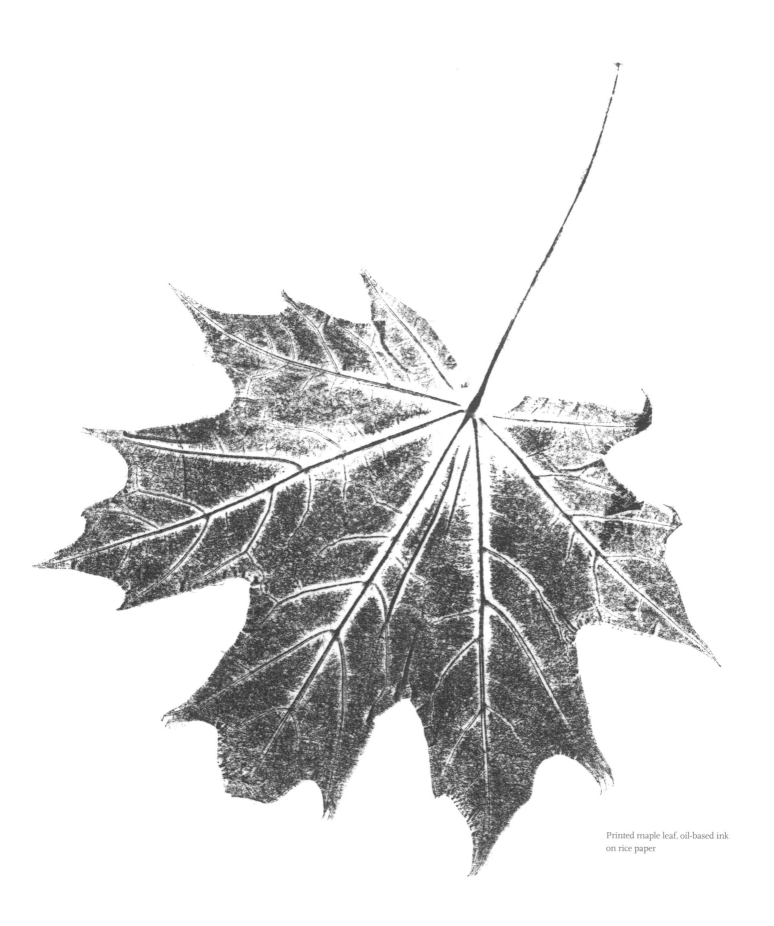

Printed maple leaf, oil-based ink
on rice paper

FISH PRINTS

Gyotaku (*gyo* means "fish" and *taku* means "rubbing") is the Japanese art of making a print from a fish. It started as a way for fishermen to record game fish, and has developed into a fascinating art form. You can print huge fish: as big as you have paper to print on! The printing replicates every detail of the fish with surprising accuracy, and the resulting images are lovely. These prints are so striking, you may wish to make several and give them away as gifts. You could design and cut your own chop mark (a distinctive mark placed on a work with an inked or uninked stamp to show ownership or authorship, or to validate an original work) into a rubber eraser (see the stamp-making exercise, page 36, for cutting tips), stamp them with red ink, and sign them. Many different materials lend themselves to fish prints, including acrylic paint, colored inks, and textile printing inks. Once you get the hang of *gyotaku*, you may be inspired to print T-shirts or scarves using textile printing inks. The primary method presented here, using water-soluble ink and a foam roller, is not traditional, but it's simpler to master. The traditional method, using sumi ink and a brush, is presented on page 56 as a variation, for the purists. Both screen-printing and sumi inks are available at most art supply stores. Purchase muslin to use for press cloths at a fabric store. It is not necessary to wash the muslin before use.

opposite
Gyotaku fish print,
water-soluble screen printing ink
on rice paper

YOU WILL NEED:
2 sheets rice paper such as Kitakata, Okawara, or Mulberry
lemon juice
one 6- to 8-inch whole fish, washed with soap and water
paper towels
blank newsprint
straight pins (optional)
protective gloves

black water-soluble screen-printing ink
one 10-by-10-inch (approximately) piece of glass or plastic, or a flat, wide plate that you don't ever intend to use for food
one 4-inch foam roller and handle
iron
1 yard muslin torn into 2 pieces to use for press cloths

Ready your printing station (see page 49).

Tear the rice paper into 6 or 7 rectangles about 3 inches bigger than your fish all around.

Sprinkle lemon juice on the fish, then wipe it clean and pat dry with paper towels. (The acid in the lemon juice takes off what is left of the slimy, protective coating on the fish skin after washing with soap and water.) Put a piece of newsprint in the center of your printing station and place the fish on it. So that the fins and tail will be somewhat level with the fish body, prop the fins and tail on small wads of paper towels, fanning them out, and secure them with straight pins if necessary (the pins must be parallel with your printing table so they don't pierce the printing paper).

Put on the gloves. Place a small amount of ink on the piece of glass or plastic. Roll the foam roller in the ink until it is evenly coated, but not too wet.

Roll ink on the fish, making sure to hit the fins and tail. Place a piece of the rice paper on top of the fish and gently rub the back of the paper with your fingers to make the print. (If your gloves are inky, remove them for this step.) Lift the paper, and set it aside print-side up to dry. Repeat to make additional prints.

When the prints are completely dry, iron the back of them with a warm iron to press out any wrinkles. Be sure to put a press cloth both under the print and on the back between your iron and the paper so that the ink won't transfer to your ironing board or to the iron.

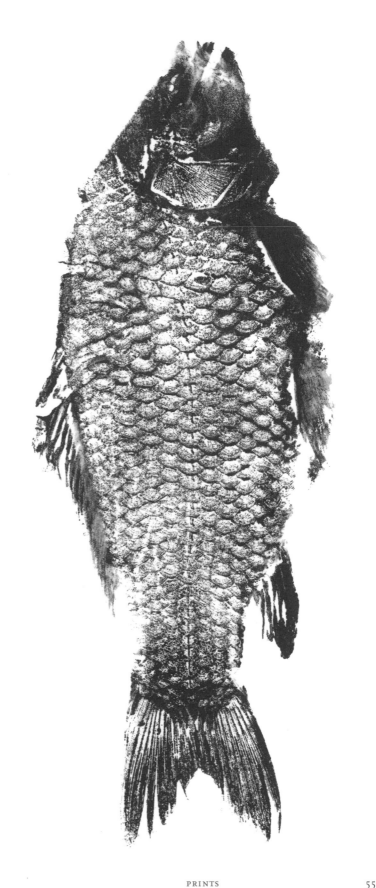

GYOTAKU WITH SUMI INK

Sumi ink and a brush are the traditional materials used in inking fish. Sumi ink is sold in stick form, which you grind and mix with water to make your own deep black sumi ink, or in premixed aqueous form. (India ink is an acceptable substitute.) Prepare the fish and proceed as directed on page 55, but instead of rolling ink onto the fish, use a 1-inch chip brush to paint a light, even coating of ink over the fish. Lightly spritz your rice paper with water before placing it on the fish, then print, dry, and press as described.

TOOL TIP: FISH

Look for a whole fish at your local fish market or grocery store, the fresher the better. You want a fish with a pronounced scale pattern that has not been trimmed, tailed, beheaded, or gutted. Carp or tile fish work well and are not too costly. Trout or salmon also work well, but may be expensive. If printing from a real fish makes you squeamish, see Suppliers, page 162, to find out where you can buy fish replicas specifically designed for inking and printing.

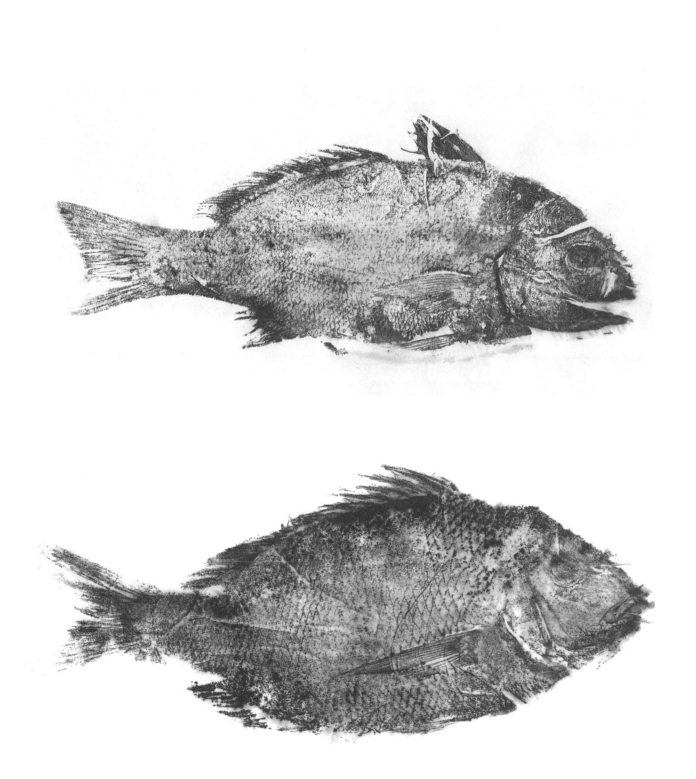

Gyotaku fish prints, india ink on rice paper

CHAPTER 3
RUBBINGS

This is a very short chapter, as making a rubbing is very simple. Have you ever made a rubbing of a gravestone? You hold a piece of paper firmly on whatever bit of text on the stone interests you, then rub across the paper with the flat edge of some drawing implement, a black crayon, say. The crayon's edge catches on any raised part of the stone, defining the recessed places and making a clear picture of the rubbed surface. You might make a rubbing of a gravestone to remember a beautiful angel carved into the rock, or to have a record of how lichens looked obscuring the name on a very old stone. All this interest in gravestone rubbings may seem morbid, but there is an ages-old tradition of people going about making rubbings of grave markers, mausoleum entrances, and brass commemorative plaques in churches or on battlefields. Some famous, well-rubbed sites have facsimile plaques and stone carvings to take a rubbing impression from so as not to wear down the originals.

opposite
Gravestone, rubbing with
black wax crayon on wax paper

Do you have a place where you walk every day? You can easily create a visual journal of your walk using the rubbing technique. How could you record your walk? The possibilities abound: tree bark, stone walls, the soles of your hiking shoes, the leaves on the ground, a pine branch or weeds, a pebbly path, a manhole cover. Where could you take rubbings on a beach walk? Consider the rough wood of the pier, the brim of your straw hat, the scallop shells you found on the sand, a piece of beach grass, a gull's feather. You could collect your rubbings in a journal, mounting them on white album pages, or take them to a copy shop and have them bound between stiff covers. Label them and include explanatory text if you like, or leave them unembellished.

In the following exercises, you will find techniques for making basic rubbings from the textured surfaces around you; using a white crayon as a resist to india ink to make negative rubbings; and building compositional structures inside a frame rubbing.

BASIC RUBBINGS

above
Safety pin, rubbing with
black wax crayon on tracing paper

below
Wood plank, rubbing with
wax crayon on tracing paper

opposite, top right
Brush, rubbing with
wax crayon on tracing paper

opposite, bottom right
Oak leaves, rubbing with
black wax crayon on tracing paper

opposite, bottom left
Shell, rubbing with
black wax crayon on tracing paper

You don't have to go to the cemetery to make a rubbing. Anything with a raised pattern or texture can make for an exciting page. Look around you. What do you see that has a texture and might make an interesting rubbing? A tile or linoleum floor? A brick wall? A woven place mat or patterned silverware? An old book with an embossed cover? A feather or leaf? How about a colander with holes in it, a slotted spoon, a screen door? Of course, the technique is incredibly simple, but you can get quite an interesting effect by varying the pressure with which you rub and by using a variety of different papers. Tracing paper is the obvious choice, but you might also try a more opaque paper such as typing paper or stationery. Look for paper with a high cotton content that is marked "acid free." You can try a lightweight printmaking paper such as Rives Lightweight, or rice paper such as Kitakata.

10 to 15 sheets 14-by-17-inch tracing paper
masking tape
black crayon

Lay a sheet of tracing paper over the textural surface you have found: a tile floor, for example. Secure the paper with masking tape at the corners. Using the side of the black crayon, rub over the paper. Rub lightly at first, then rub harder as the texture begins to become apparent on the paper. Remove the tape and lift the paper from the floor. What do you see? How does the rubbing of the floor differ from the floor itself?

To make a rubbing of a small object, you may find that you have to tape the object down. For example, to make a rubbing of a coin, use a small piece of masking tape rolled sticky-side out into a cylinder to secure the coin to your work surface. Place a piece of tracing paper over the coin and tape the paper down. Using the side of the black crayon, rub over the paper and coin. How distinct can you make the rubbing picture? Don't worry about the scuff marks or extraneous marks made by the crayon. This adds to the interest of the image.

To make a rubbing of a three-dimensional object like a box, wrap the tracing paper around the object as you would if you were wrapping a gift, then rub the crayon all over the top, bottom, and sides of the object. Unwrap the object and flatten the paper. When you are making rubbings of dimensional objects, you can flatten the rumpled paper by leaving it overnight under some heavy books.

NEGATIVE RUBBINGS

You can make a negative rubbing simply by using dark paper and white crayon to make the reverse of the rubbings described on page 61, with the image in white and the background in black. Another option is the resist technique: Make a rubbing as directed above but using white crayon on white paper, then use a paintbrush to paint the surface of the paper with india ink. With a dampened paper towel, gently wipe the ink off the waxy crayon areas, exposing the rubbing in bright white.

Coins, white crayon, india ink on paper

Carved wood, white crayon, india ink on paper

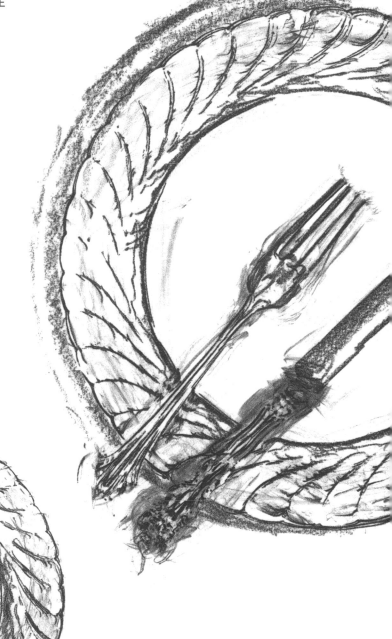

Dinner plate and silverware,
rubbing with black wax crayon on
tracing paper

BUILDING A COMPOSITION IN A FRAME

By making a rubbing of a frame such as a
textured picture frame or a dinner plate with a
raised edge, you create a defined area within
which you can build a composition that plays
off the unique qualities of rubbings. Build
layers of light and dark; of heavy, intricate
texture and delicate areas. You can use the
textural surfaces you found in the preceding
exercises to make an abstract composition. If
you have cut stencils in any of the previous
chapters, you can use them to make rubbings
of specific images.

Dinner plate,
architectural detail from
cover of an old bible rubbing
with black wax crayon
on tracing paper

CHAPTER 4
GOUACHE RESIST

Artists have been using resist materials for centuries as a way to make marks on fabric. Throughout Indonesia, wax is used as a resist in batik dyeing to create patterns on fabric. The wax is applied with a brush, tjanting needle, or copper stamp, then the fabric is dyed. Where the wax was applied, the original fabric color is protected from the dye, as the wax repels the dye water. The wax is then removed, but the patterns remain. In China, a rice-paste amalgam is used as a resist for fabric in place of wax. Watercolorists among readers here are probably familiar with liquid frisket, a rubber cement–like resist applied to watercolor paper to protect the white of the paper from the paint. Each resist technique has its own distinctive qualities.

Gouache is a water-based opaque paint. It is made from ground pigments bound in gum arabic, a secretion of many trees and plants that hardens when it dries but remains soluble in water. The painted surface of gouache is matte, almost chalky, and has a denseness to it. Gouache is often the choice of designers and illustrators for its uniform appearance and ease of translation to print media. The denseness and water solubility of gouache make it ideal as a resist. In this chapter, you will learn to apply white gouache to paper. Once the gouache is dry, you can cover your white-on-white painting with waterproof india ink. When placed under cool running water, the water-soluble gouache rinses away and the waterproof ink stays. The page is transformed. Ordinary marks are changed into rugged textures, delicate washes, and wonderful surprises.

opposite
Sprayed gouache as resist, india ink, fern as stencil

Some of the exercises in this chapter call for the use of sprayed paint and natural materials as stencils. These projects produce images that have the look of strange, primitive photographs, full of mysterious shadows. Gouache can also be applied with brushes or sponges or spattered, to achieve different textures. You can explore these variations in the "Painted Gouache Resist" section, where a series of different paint application techniques are used with Mylar cutout stencils.

SPRAY GOUACHE

It is useful to think of this exercise as primitive photography, in a way, with the spray of white gouache acting as the "light." This is a helpful way to think about the paint application: When you spray the paint, or "light," on your stencils, spray from only one direction, the way a sunbeam falls on an object and creates a shadow. This helps ensure a crisp image. Collect various natural materials to use as stencils: twigs, grasses, wheat stalks, cuttings from your flower garden or house plants, dried flowers or ferns from a bouquet. In lieu of natural materials, pasta can provide an interesting array of shapes for stenciling.

YOU WILL NEED:
¼-inch to 1-inch masking tape
3 sheets heavyweight white or cream-colored
 paper, torn into rectangles approximately
 7 by 10 inches
dried ferns, grasses, twigs, plant cuttings,
 and/or pasta to use as stencils
protective gloves
respirator
Preval spray gun filled with prepared white
 gouache (see pages 68–69)
waterproof india ink
clean, wide-mouthed plastic container with lid
 (a yogurt or cottage cheese container
 works well)
one 2-inch sponge brush

With the masking tape, mask out a margin all around the edges of a rectangle of paper, so that the outside edge of the masking tape is flush with the outside edge of the paper; do not tape the paper to the work surface. Choose an object from among your stencil materials and place it on the paper. If you are using an object that has a wide surface, like a leaf, use small pieces of masking tape, rolled sticky- side out into cylinders, on the back of the object to secure it to the paper. If you are using delicate grasses or weeds, tape the

objects to the masking-tape border, rather than your work surface, so that you can set the whole assembly aside to dry before removing the stencils and tape. Whatever taping method you use, make sure nothing slips or moves while you are spraying, or your image will be blurry.

Put on the gloves and respirator. Using the spray gun, spray the gouache across the stencil onto the paper. Because you can't see the gouache on the paper very well, this is when you have to summon the thought of light shining on the object, causing it to cast a shadow on the paper beneath. Spray lightly and evenly in a single application, holding the spray bottle at a consistent angle as you do—you must be sure not to change the angle or spray under the stencil where it stands away from the paper. If you were spraying easily visible paint, you would probably do this automatically, but here you will have to do it mechanically, trusting the written instructions.

Repeat to make additional samples, choosing stencils from among your other stencil materials. Try spraying once, then letting that coat dry and spraying another light, even coat on the same sample. On another sample, try

spraying a super-light coat, a bare hazing of paint. Try spraying a heavy coat of paint on another sample. When the gouache has dried thoroughly, remove the stencils, leaving the taped borders.

Pour a small amount of ink into the plastic container. Using the sponge brush, paint ink onto the gouache-sprayed pages, completely covering all the white paper and white paint marks. Paint from side to side or from top to bottom, trying not to overlap your strokes too much.

Let the ink dry thoroughly, then remove the border tape from all of your samples. In a sink or bathtub, run cool water over the paper. You will see the white gouache beginning to loosen and expose the white paper. If necessary, rub the surface gently with your fingers to dislodge all of the gouache, leaving only the ink. Do not use very warm water, as it causes the gelatin sizing (usually made from animal product, such as cows' hooves) of the paper to break down quickly, and that causes the paper's surface to erode slightly. Also, water that is too warm will start to cook the paper's cellulose fiber, and compromise the integrity of the paper. Just as you wouldn't wash lettuce and carrots in hot water before making a salad, don't do the same to your paper, as both have a cellulose structure. Do not rub the paper too hard as it can take away more of your image than you intended by scrubbing away the cotton fibers along with the gouache. Set the washed pieces aside to dry thoroughly.

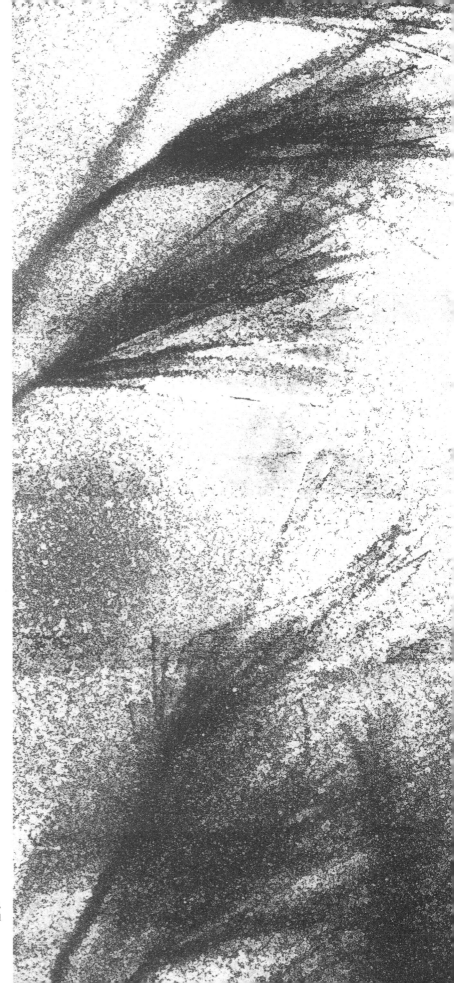

Sprayed gouache as resist,
india ink, pine bough as stencil

Gouache-density test, sample of
resist qualities of six successive
sprays of gouache

TOOL TIP: GOUACHE

Gouache is expensive, and if you love this
technique, you will need a lot of it. A good,
less expensive substitute is Rich Art Moist
Watercolor in Poster White (see Suppliers,
page 162). This gouache-like paint is thick
enough to resist the ink, and much
cheaper than buying white gouache by the
tube. Be sure to shake the paint before
using, as it often separates in the jar. If
shaking doesn't combine the paint, then
stir it well. To prepare the paint for spray-
ing, combine approximately 1½ ounces of
paint with ½ cup warm water. Stir or
shake to combine. Adjust as necessary to
achieve the consistency of dairy half-and-
half. (The consistency of Rich Art paints
varies, sometimes a jar will contain very
thick paint and sometimes it is more
fluid.) When you are done with the Rich
Art for the day, lay a small piece of plastic
wrap over the mouth of the jar, before
screwing the lid back on. This prevents
the paint from drying out in the jar.

THE GOUACHE DENSITY TEST

Because every sprayer is different, you may want to make a test sample to see how many times you have to spray to get a clear image. Tear a piece of paper into a 4-by-8-inch rectangle. Spray the entire piece of paper once lightly with gouache. Let dry. Cut or tear another piece of paper—newsprint or typing paper will do—into strips about 1 inch wide and 4 inches long, to use for masking. Place one of the masking strips on the painted paper on the right edge, covering a 1-inch-wide strip. Secure the strip lightly with tape at the ends and spray the whole paper again with another light, even coat. Let dry thoroughly. Mask off the next inch to the left of the first, spray another light, even coat, and let dry. (Usually a sample of 3 sprays will tell you how much gouache you will need; however, build your own sample with as many layers as you wish, as you may have thinned your gouache more or less than in this test, giving you different results.) When the gouache is thoroughly dry, remove all the masking strips. Paint the paper with ink, let dry, and wash off.

When painted on with a brush, the gouache resists a different amount of ink, depending on how much it is thinned with water. You can test it similarly to the way you did the spray. Pour a little gouache into each of 4 or 5 containers. Leave one undiluted, just as it came from the jar, then add water to each of the remaining containers in slightly increasing amounts. On another 4-by-8-inch piece of paper, paint a 1-inch swath of paint from each container, beginning with the least diluted and ending with the most. Let dry thoroughly. Paint the paper with ink, let dry, and wash off.

Gouache-density test, sample of resist qualities of gouache thinned with water in four different proportions.

ADDING IMAGERY TO TEXTURE

If you cut a stencil of a deer (pattern, page 161) and add it to a forest of branches, something happens: The forest of branches changes scale and looks like a forest of trees, and the viewer begins to construct a simple narrative, as in "What is that deer doing in those trees?" Suddenly the marks on the page, really just abstract dark and light, start to intimate a story. Similarly, you could add a bird to a field of flowers, rain to a rural landscape, clouds to a clear sky.

What happens when you use a stencil made from the small and large landscape patterns on page 161? The dried hydrangea blossoms can seem like clouds over the small landscape stencil.

Try placing the "ground" half of the small landscape stencil on a piece of paper so that the lower part of the paper is totally covered, and place the dried hydrangea blossoms on the upper half. (The hydrangea create a cloud-like effect with petals that are small and clustered together; you could try using other flowers for the same effect, like geraniums clustered together on the page, for example.) Spray this setup lightly and evenly. Let dry thoroughly, then remove the landscape stencil and the flowers. Then, put the "sky" half of the small landscape stencil on the top half of the page, making sure the whole hydrangea "sky" is covered, and spray gouache on the lower half of the page, concentrating the spray on the horizon line. Let dry, paint with ink, and wash off. What do you see?

Using the same method, combine wheat stalks (available at many florists) with the large landscape stencil.

In this sample, does the mark left by spraying gouache on dried fettucini look like rain falling? Or beams of light?

Sprayed gouache as resist, india ink, fettuccini, small landscape stencil (pattern, 161)

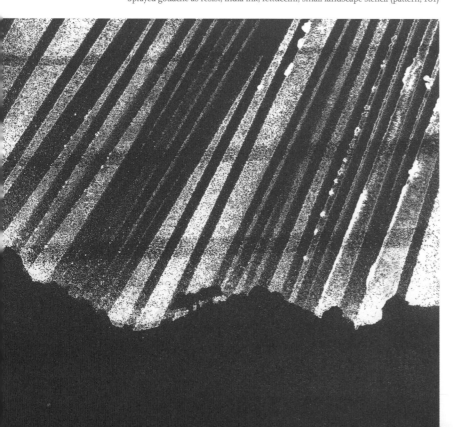

Sprayed gouache as resist, india ink,
dried wheat stalks, large landscape stencil (pattern, page 161)

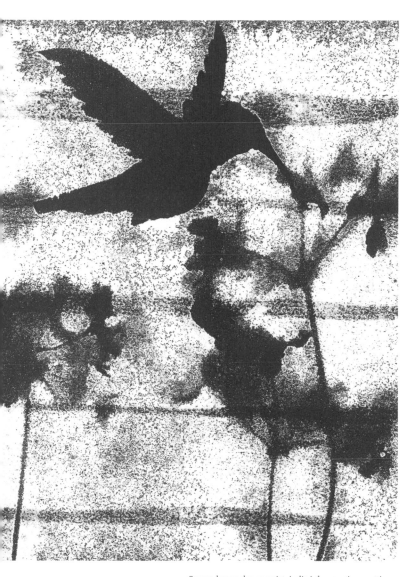

Sprayed gouache as resist, india ink, geranium cuttings,
hummingbird stencil (pattern, page 161)

Sprayed gouache as resist, india ink, hydrangea blossom,
small landscape stencil (pattern, page 161)

PAINTED GOUACHE

You can paint gouache rather than spray it and achieve interesting results, marks less like shadows or photographs than the sprayed images but with an evocative quality all their own. In this exercise, you will use different means of applying gouache to paper, and explore the idea of a "series." A series is when more than two artworks are unified by a common idea and are meant to be seen together. That common idea might be the imagery, the colors used, the size of the works, or the way they are presented. A series might suggest a narrative in the way that it is arranged to be viewed, or could be the beginning of an artist's book of images, with or without text. There are numerous ways to approach the concept of the series. Try the one below, and experiment with some of your own.

YOU WILL NEED:
one 12-by-12-inch piece .004 ml matte Mylar
	or clear acetate
deer pattern (enlarged per the instructions on
	page 160)
pencil (or ballpoint pen if you are using clear
	acetate)
self-healing cutting mat or smooth cardboard
X-acto knife with no. 11 blades
¼-inch to 1-inch masking tape
2 sheets heavyweight white or cream-colored
	paper, torn into rectangles approximately
	7 by 10 inches
protective gloves
white gouache
2 clean, wide-mouthed plastic containers with
	lids (yogurt or cottage cheese containers
	work well)
waterproof india ink
natural sponge
one 2-inch foam brush
one 2-inch chip brush
toothbrush
popsicle stick or chopstick
small paintbrush

Place the Mylar over the deer pattern and trace around the pattern with the pencil. Place the Mylar tracing on the self-healing mat and use the X-acto knife to cut along the lines. Save both the border around the deer and the deer itself. (In the following, the two stencils will be called the "deer border stencil" and the "deer stencil" to differentiate them.)

With the masking tape, mask out a margin all around the edges of a rectangle of paper, so that the outside edge of the masking tape is flush with the outside edge of the paper; do not tape the paper to the work surface. This makes a beautiful edge when the tape is removed, and taping a border on all of the pieces in this series unites the deer images with a consistent look.

Place the deer stencil on the paper, using small pieces of masking tape rolled sticky-side out into cylinders to secure it.

Put on the gloves. Pour some gouache into one of the containers and some ink into the other. You may have to add a little water to the gouache, making it the consistency of heavy cream for best results. Using the natural sponge, apply gouache all over the paper and over the deer stencil. Let dry, then remove the deer stencil. Use the foam brush to coat the paper with ink, let dry again, and remove the border tape. In a sink or bathtub, run cool water over the paper. You will see the white gouache beginning to loosen and expose the white paper. If necessary, rub the surface gently with your fingers to dislodge all of the gouache, leaving only the ink. Set the washed piece aside to dry thoroughly.

Mask out a border all around the edges of another piece of paper and secure the deer stencil to the paper. Using the chip brush, paint strokes from the deer stencil out to the edges of the paper with gouache, radiating like beams of light. Do some strokes with a lot of paint on the brush, and some with a drier brush. Brush away from the stencil so as not to push paint under it. Let dry and remove the stencil. Coat the paper with ink, let dry again, remove the border tape, and wash the paper under cool running water. What do you see?

Secure the deer stencil to a third piece of paper with a taped border. This time spatter around the stencil, using the toothbrush: Dip the toothbrush in gouache. Hold it bristle-side up, with the brush end pointing down away from you and tipped down at the paper. Pull a popsicle stick or chopstick across the brush toward you. The bristles will spring forward and spatter paint on the page. Spatter slightly more at the edge of the stencil. Let dry and remove the stencil. Coat the paper with ink, let dry again, remove the border tape, and wash the paper under cool running water.

Put aside the deer stencil and place the deer border stencil on another piece of paper with a taped border. If there is paper beyond the edges of the deer border stencil showing, mask them out with strips of newspaper. You may wish to tack these masking strips in place by taping them lightly to the stencil. Now spatter gouache in the cutout area of the stencil. Let dry and remove the stencil. Coat the paper with ink, let dry again, remove the border

continued

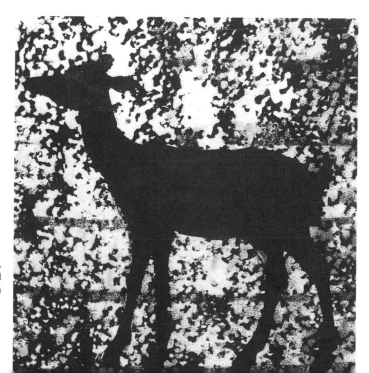

Sponged gouache as resist,
india ink, deer stencil
(pattern, page 161)

tape, and wash under cool running water. What do you see? A constellation? A night scene? Snow?

You can make a dramatic spatter, larger than the toothbrush method, with the chip brush. Get some gouache on the brush. Secure the deer stencil to another piece of paper with a taped border and fling the paint from the brush at the paper, as if the brush were a fishing pole and you were casting a trout line. Let dry and remove the stencil. Coat the paper with ink, let dry again, remove the border tape, and wash under cool running water.

Place the deer border stencil on another piece of paper with a taped border. Using the chip brush with a very little gouache on it, paint striations on the cutout animal shape. The

dryish chip brush will make the striations for you, as the bristles will separate somewhat. Imagine your brush following the curve of the deer's flank and going around his legs; your brushstrokes need not be straight. Let dry and remove the stencil. Coat the paper with ink, let dry again, remove the border tape, and wash under cool running water.

Now place the deer stencil on another piece of paper with a taped border, and trace lightly around it with the pencil. Remove the stencil and set it aside. With the small paintbrush,

Spattered gouache as resist, india ink, deer stencil (pattern, page 161)

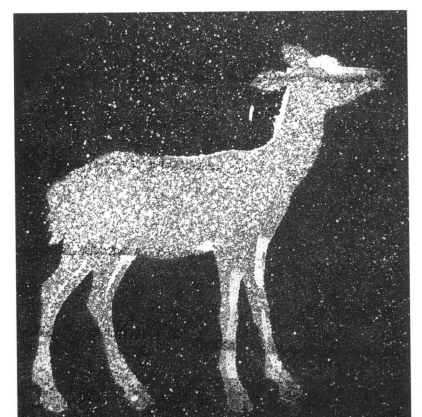

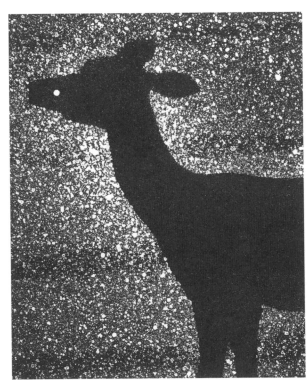

Spattered gouache as resist, india ink, deer border stencil (pattern, page 161)

paint gouache around the outside of the line that describes the deer. Stay loose; don't worry about being neat, or that you can't see what you are doing. Let dry, coat the paper with ink, let dry again, remove the border tape, and wash under cool running water. How do your marks look? Relaxed, fluid? Can you see the deer? What if you did another like this and painted within the lines? What if you tried to paint the deer's hair with a chip brush? Where would his eye be? Paint it in, and process as before. What do you see?

Put all of the finished deer samples together on your work surface and look at them. Do they look like they belong together? Why? Is there one or more that looks out of place? Why? Remove that one from the series. Can you rearrange the deer samples to be in a particular order that makes sense to you? Do they suggest a narrative, or story? Is there a step missing in the series? What would it be? How could you present this series? Hanging together on a wall? Bound together in a book? In a box?

Gouache as a resist painted around deer stencil (pattern, page 161), india ink

WHITE ON WHITE

Though we are not going to do so in these exercises, one can use colored gouache with this technique. Colored gouache leaves an interesting stain on the paper after the ink is washed off, but for our purposes, white gouache on white paper is the most instructive. Because you will be painting white onto white, you will have difficulty seeing the marks you make at first, and will have to proceed mechanically, trusting the written instructions to ensure a distinct impression. If you find it too disconcerting not to be able to see your marks, you can add a dot of yellow or blue gouache to your white so that you are painting with an off-white, or use an off-white paper, such as Rives BFK in cream. But try using white on white first—not seeing prevents you from getting uptight about the marks you are making, and that freedom may lead to new discoveries.

ACRYLIC GEL MEDIUM RESIST

Acrylic gel medium is typically mixed with acrylic paint to change the texture of the paint or to give it a more transparent effect on the canvas. The medium can also be used as a varnish over the surface of a painting to change the surface quality from matte to gloss. Just like acrylic paint, acrylic gel is soluble in water when wet and becomes impervious to water when dry; it is therefore an effective resist because once the medium dries on the paper, it resists whatever water-based material is painted over it. The technique is simple: Apply acrylic medium to paper, let it dry, then rub the paper surface all over with ink and water. The medium resists the ink and maintains the white of the paper underneath—mostly. It is the "mostly" that is interesting: The ink makes its way to the paper where the medium was applied thinly, and here and there eats into the surface of the medium. This makes the paper look like something old and worn, like an eroded, ancient wall painting or something found in an archeological dig.

opposite
Acrylic gloss medium, india ink

In this chapter, you will learn to use acrylic gel medium to create mysterious-looking surface textures and the illusion of depth using transparent layering. You'll also use plastic grocery bags and bubble wrap to create the look of fossil-encrusted stone.

MATTE & GLOSS MEDIUMS

As you'd expect, gloss medium is shiny and matte medium has a dull finish. Gloss medium resists more than matte medium because it has a harder, slicker surface when dry, and inks wipe off of it easily. Matte medium, because it resists less, can make interesting aged-looking surfaces, as inks and paints eat down through the resist in places. In this exercise, you will experiment with both to create different textures.

YOU WILL NEED:

matte acrylic gel medium (medium viscosity)

4 clean, wide-mouthed plastic containers with
 lids (yogurt or cottage cheese containers
 work well)

gloss acrylic gel medium (medium viscosity)

waterproof india ink

protective gloves

natural sponge

1 sheet heavyweight white or cream-colored
 paper, torn into rectangles approximately
 7 by 10 inches

one 2-inch chip brush

clean cotton towel

This exercise requires a drying step, so you may want to work on more than one sample at once. You'll find your own rhythm.

Put some matte medium in one of the containers, some gloss medium in another, ink in the third, and water in the fourth.

Put on the gloves. Dip the sponge into the container of gloss medium. Sponge medium all over a rectangle of paper, sponging more in some places and less in others. Set aside and let dry.

Dip the chip brush into the matte medium and paint across a second piece of paper. Try to do the whole page with one brushful so that there are thicker and thinner areas of medium. Set aside and let dry.

Get some matte medium on the chip brush and spatter medium onto another piece of paper by flicking your wrist toward the paper. Repeat with the gloss medium. Set aside and let dry.

When the samples have thoroughly dried, dab a little ink onto them here and there, dip a towel into the water, and rub the damp towel into the wet ink and dry medium. See if you can make some very dark areas "behind" the dry medium, as well as some very light areas. As the ink and water dry slightly while you are working into the paper, you can re-wet the towel with water and wipe as much ink as you wish off of the surface of the dry medium. What do you see? Stone? Rain? Something else?

Acrylic matte medium, india ink

TRANSPARENT LAYERS

By adding different amounts of black acrylic paint to gloss or matte mediums, you can make transparent grays of different values (lightness and darkness) and experiment with layering them to create the illusion of depth.

YOU WILL NEED:

one 8-by-8-inch piece .004 ml matte Mylar or
 clear acetate
hummingbird pattern (enlarged per the
 instructions on page 160)
pencil (or ballpoint pen if you are using clear
 acetate)
self-healing cutting mat or smooth cardboard
X-acto knife with no. 11 blades
protective gloves
gloss acrylic gel medium (medium viscosity)
5 clean, wide-mouthed plastic containers with
 lids (yogurt or cottage cheese containers
 work well)
1 sheet heavyweight white or cream-colored
 paper, torn into rectangles approximately
 7 by 10 inches
natural sponge
black acrylic paint
waterproof india ink
one 1-inch chip brush
clean cotton towel

Place the Mylar over the hummingbird pattern and trace around it with the pencil. Place the Mylar tracing on the self-healing cutting mat and use the X-acto knife to cut along the lines. Save both the border around the hummingbird and the hummingbird. You can use both as stencils, but for this exercise we will use only the hummingbird border stencil.

Put on the gloves. Put approximately 2 tablespoons gloss medium in one of the plastic containers. Place the hummingbird border stencil on a rectangle of paper. Using the sponge, apply the gloss medium to the cutout area of the stencil. Lift the stencil, place it on another part of the paper, and apply medium again. Repeat a third time. Let dry.

In the second plastic container, combine 2 tablespoons gloss medium with a tiny dab of black acrylic paint. Mix this thoroughly to create a light gray medium. Carefully place the stencil on top of the first clear hummingbird you painted, but shift it slightly so that it is just slightly off center. Use the sponge to apply the light gray gloss medium to the paper inside the stencil. Repeat with the other 2 hummingbird images. Let dry.

In the third container, combine 2 tablespoons gloss medium with a larger dab of black acrylic paint. Mix thoroughly to create a slightly darker gray medium. As before, place the stencil atop the hummingbird you first painted, but shift it slightly off center. Paint and repeat as before. Let dry.

Put some ink in the fourth container and some water in the remaining container. Use the chip brush to paint water here and there across the entire piece of paper. Use the same chip brush to dab ink on the paper as well. The ink will run into the water in places, making an interesting variation in value. Rub gently with the towel. Add a little more ink here and there and keep rubbing. What do you see? You can make an infinite number of different valued gray layers. Try adding straight black acrylic paint.

On another piece of paper, use the above technique to crowd the page with hummingbirds of all different values. If you like, dry off the stencil and flip it over so that all the birds aren't flying the same way.

Take your samples outside or to a bright window and tilt them back and forth in the light. How does the shininess of the gloss medium change the value pattern in your picture when the light hits the surface of the paper? How does the shininess change as more black acrylic is added to the medium? How could you make use of this effect if the picture were hanging on the wall?

Acrylic gloss and gel mediums and black acrylic paint, india ink

WOOD-GRAIN PATTERNS

The wood-graining tool, or rocker, is used by decorative painters to make bold, simulated wood-grain patterns in paint. The surface of the tool has concentric half-circle ridges, and you rock the tool back and forth to make the wood-grain pattern. A wood-graining tool can make interesting marks on paper, as well as on the wall. The striations can also evoke things other than wood: a landscape, flowing water, moire silk.

YOU WILL NEED:
protective gloves
chip brushes of various sizes
gloss acrylic gel medium (medium viscosity)
1 sheet heavyweight white or cream-colored paper, torn into rectangles approximately 7 by 10 inches
3 clean, wide-mouthed containers with lids (yogurt or cottage cheese containers work well)
black acrylic paint
wood-graining tool
paper towels
matte acrylic gel medium (medium viscosity)
waterproof india ink
clean cotton towel

Put on the gloves. Use a chip brush to paint gloss medium all over one rectangle of paper. Set aside to dry.

In one of the plastic containers, combine 2 tablespoons gloss medium with 2 tablespoons black acrylic paint. Use a clean brush to paint the mixture over the entire surface of the dried gloss medium. Immediately—before the second layer of medium dries—drag the wood-graining tool through the paint from the top of the paper to the bottom, rocking it gently as you go. What do you see? Turn the page so that the striations are horizontal. What else do you see? Set the sample aside to dry. Wash the wood-graining tool with soap and water and dry with paper towels.

Next, paint gloss medium in 3 or 4 wet swaths down a clean piece of paper, leaving some of the paper untouched. Before the medium dries, drag and rock the wood-graining tool along the swaths, from top to bottom. Let dry.

On another piece of paper, dab blobs of the matte medium, and before it dries, drag and rock the wood-graining tool through the blobs. Let dry.

Put some ink in the second container and some water in the remaining container. Use a chip brush to paint water here and there across all of the dried samples. Use the same chip brush to dab ink on the rectangles as well. The ink will run into the water in places, making an interesting variation in value. Rub gently with the towel. Add a little more ink here and there and keep rubbing. What do you see? Wood? Or ghosts? Repeat to make additional samples.

Acrylic gloss medium, black acrylic paint, wood-graining tool

Acrylic gloss medium, wood-graining tool, india ink

Acrylic matte medium, wood-graining tool, india ink

FOSSILS

Acrylic gel medium resist already makes for an interesting aged-looking surface, but when plastic materials are pressed into the acrylic, ink, and water while they are drying, images that look like ancient crustaceans embedded in stone appear. This technique can make a beautiful texture within an artwork, or serve as the basis for a series of fossil paintings. Watercolorists use a variation on this technique to make lively backgrounds for their work, or as a starting place for florals.

YOU WILL NEED:
plastic drop cloth
scissors
plastic grocery bags
protective gloves
waterproof india ink
2 clean, wide-mouthed plastic containers with
 lids (yogurt or cottage cheese containers
 work well)
one 1-inch chip brush
matte acrylic gel medium (medium viscosity)
gloss acrylic gel medium (medium viscosity)
1 sheet heavyweight white or cream-colored
 paper torn into rectangles approximately
 7 by 10 inches
needle and thread

Cover a protected area of your work space with the drop cloth, for drying samples, as they will be particularly juicy and the drying time for this technique is long, preferably overnight.

Cut 4 rough squares from 2 plastic bags, approximately 10 by 12 inches.

Put on the gloves. Put some ink in one of the plastic containers and some water in the other. With the chip brush, apply dabs of matte and gloss medium in equal amounts, about 1½ inches apart, all over a rectangle of paper. Dab some ink here and there, and then water here and there, on the same paper. The ink and water and medium should all begin running together.

Rumple a plastic bag square somewhat and press it onto the wet surface of the paper. Make sure the plastic covers most of the page. Very carefully, set aside to dry overnight. Make a few more samples like this, trying both gloss and matte mediums and varying amounts of medium, water, and ink—on one you might put just a drop of ink and a lot of water, and on another, several drops of ink. Each image will be different, even if you don't vary your technique at all. You can also try plastic wrap instead of plastic bags, or bubble wrap, both the big-bubble kind and the smaller bubbles.

Cut 4 more rough squares from 2 plastic bags.

Thread the needle and make a big knot at the thread end. Stitch across the middle of a plastic bag square from one side to the other. Make great big stitches (no sewing skill required) and tug the thread gently so the stitching pulls in to gathers. Put medium, ink, and water on a piece of paper as above and squish this sewn piece of plastic onto the wet surface. Set aside to dry overnight.

continued

Crumpled plastic pressed into
wet acrylic matte medium and india ink

Sew another plastic bag square, pulling the gathers tighter or leaving them loose. Sew another one with the stitches near the edge of the square, and one with the stitches going in a circle. Press these into medium, ink, and water on paper as before, and set aside to dry overnight.

The overnight drying time ensures the best results. If you must peek, carefully peel back the plastic after 3 hours to see what's underneath. If you find a wet mess, you'll have to wait; just press the plastic back down on the paper and let it dry longer.

When the samples are dry, gently remove the plastic. There might be a little dampness still, but that will dry quickly with the plastic off. What do you see? Vertebrae? Wisteria blossoms? Are some more fossil-like than others?

Crumpled plastic pressed into wet acrylic gloss medium and india ink

Crumpled plastic pressed into wet acrylic matte medium and india ink, then a pen line describing a "fossil" visible in the resulting marks

ARCHEOLOGY

Lay a piece of tracing paper over a sample that looks particularly fossil-like. Secure the tracing paper to the work surface with masking tape. With a pencil, trace around the parts that describe the flora or fauna that you see trapped in the "stone."

You can play archeologist with the samples you create this way. What is the scientific name of the creature you have found? From what era? You could display the images and their overlays bound in a book so that a reader can see the successive steps; hanging on the wall; or in a glass case like a natural history museum display. Think about what the land looked like where these animals roamed. Or were they ocean creatures? Could you write a description of these places? What did the animal eat? Or was it eaten? By what? Could this information be incorporated into an artwork that includes these fossil images?

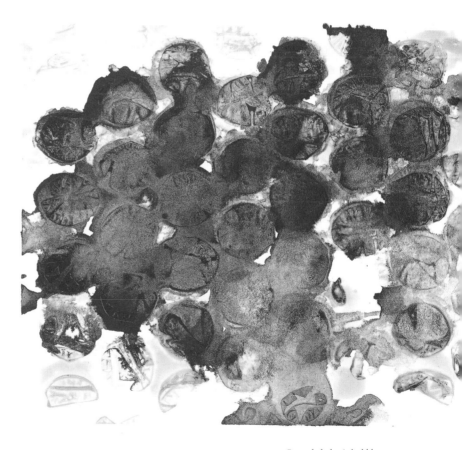

Crumpled plastic bubble wrap pressed into wet acrylic matte medium and india ink, then a pen line describing trilobites visible in the resulting marks

INVISIBLE INK

You may have used lemon juice as invisible ink when you were a kid. Remember? You wrote a secret message on a piece of paper using a cotton swab dipped in lemon juice. Once it was dry, you passed it to a friend. Your friend held the blank paper over a lightbulb and watched golden letters appear as if by alchemy. The science behind the magic is simple: Lemon juice browns at a lower temperature than the paper, so the invisible message darkens before the paper burns.

The techniques for applying lemon juice in this chapter are no different from the various application techniques you have learned in previous chapters—painting or spraying over stencils, etc. What makes these exercises unique is that same wonder you experienced as a child—the wonder of creating invisible shapes and textures that appear later magically. The baked lemon juice turns a beautiful, delicate brown, evoking sepia photographs, old letters, treasure maps, or antique vellum documents.

The exercises here use sprayed lemon juice and slightly thickened lemon juice, along with found natural materials, to make interesting, aged-looking pictures. You will also make your own magic texts using a Mylar cutout stencil and a backwards-writing technique borrowed from Leonardo da Vinci. Bountiful and inexpensive, lemon juice is a wonderful material for making beautiful marks on paper.

opposite
Sprayed lemon juice on paper, weeds as stencils, baked to reveal image

SPRAY PAINTING WITH LEMON JUICE

Spraying lemon juice on paper and baking it leaves an aged-looking mark, enhanced by darker edges where the lemon juice was sprayed heavily and pooled, creating watermarks. The main exercise involves painting with lemon juice using natural and found objects as stencils, and the variation offers the additions of salt and water for a sparkling texture.

YOU WILL NEED:
baking sheet
masking tape
1 sheet medium to heavyweight white paper,
 torn into rectangles approximately 7 by 10
 inches
dried ferns, grasses, twigs, plant cuttings, or
 lace to use as stencils
1 cup bottled lemon juice, strained
Preval spray gun, atomizer, or spray diffuser
pencil

Place a baking sheet in the center of the oven and preheat the oven to 350°F.

With the masking tape, mask out a margin all around the edges of a rectangle of paper, so that the outside edge of the masking tape is flush with the outside edge of the paper; do not tape the paper to the work surface. Choose an object from among your natural materials and place it on the paper. If you are using an object that has a wide surface, like a leaf, use small pieces of masking tape, rolled sticky-side out into cylinders on the back of the object, to secure it to the paper. If you are using delicate grasses or weeds, tape the objects to the masking-tape border rather than your work surface,

so that you can set the whole assembly to dry before removing the stencils and tape from the samples. (The masked-out margin also makes a beautiful edge when the tape is removed.) Whatever taping method you use, make sure nothing slips or moves while you are spraying, or your image will be blurry.

Put the lemon juice in the bottle of the spray gun and spray across the stencil onto the paper. Because you can't see the lemon juice on the paper, you may be tempted to spray a lot of lemon juice: Don't. Spray lightly and evenly in a single application, holding the gun at a consistent angle as you do—you must be sure not to change the angle or spray under the stencil where it stands away from the paper.

Repeat to make additional samples, choosing stencils from among your other materials. Leave the objects taped on and let the sprayed lemon juice dry thoroughly before removing the objects and the tape. Make a tiny pencil mark in a corner of each paper to indicate the "juice side."

continued

Sprayed lemon juice on paper, dried flowers as stencils, baked to reveal image

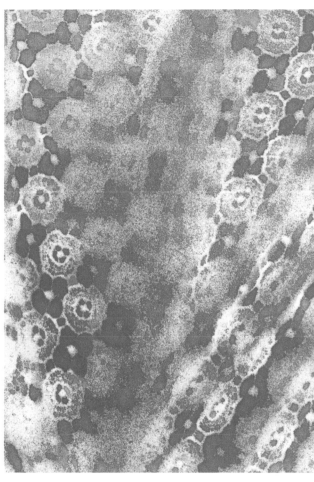

Sprayed lemon juice on paper, lace as stencil, baked to reveal image

Sprayed lemon juice on paper, delicate branch as stencil, baked to reveal image. The vertical line in upper right quadrant is the mark of the oven rack. You can avoid this by baking your samples on a cookie sheet.

Bake one page at a time, juice-side up, on the hot baking sheet in the oven. Forty-five seconds is usually long enough to get a good image. (As some ovens are hotter than others, watch carefully at first to see how much time it takes to get a satisfactory image.) You will begin to see a faint golden image, perhaps just at the edges at first, and then all over. Use tongs to remove the paper when it's done. You will have to decide for yourself when it looks good, although as a rule of thumb, leave a piece in longer than you think you should to get it really brown. Do not let the paper burn. Keep a good watch on the time, and record in pencil on the back of each experiment what you did and how long it was in the oven.

Without the baking sheet, the oven rack will make an impression on the paper, like sear marks on a grilled steak. With the sheet, the heat is more evenly distributed. You might like the oven rack marks, though; try baking one piece of paper directly on the rack.

SALT

Salt crystals on the lemon juice leave starlike spots after baking. Piles of salt create very white spaces. To use salt in your lemon juice pieces, spray lemon juice on paper as above. Drip a little water on the paper, then sprinkle on some table salt. Let dry thoroughly, then brush off the salt before baking. Experiment with coarse and fine salts to see the different marks they make.

Sprayed lemon juice, water and salt on paper, baked to reveal image

SPRAY PAINTING WITH THICKENED LEMON JUICE FOR MORE CONTROL

The unevenness of the marks in the previous exercise is caused by the pooling of the lemon juice. To achieve a more uniform spray, you can add methyl cellulose, an adhesive found in most wallpaper pastes, to give the lemon juice more body and to discourage this pooling. The thickened juice will also allow you to make a clearer, more controlled image. Methyl cellulose, available at hardware and paint stores in the wallpapering section and at art supply stores that carry bookbinding supplies, comes in a powder form that must be mixed with water. Read the label: You want the kind that contains only methyl cellulose and no additional ingredients. Buy the smallest amount you can—a little goes a very long way. Once mixed with water, it will keep, covered, for up to 3 months at room temperature.

YOU WILL NEED:
baking sheet
1 teaspoon methyl-cellulose powder
Preval spray gun, atomizer, or spray diffuser
8 oz. bottled lemon juice, strained
masking tape
1 sheet medium to heavyweight white paper, torn into rectangles approximately 7 by 10 inches
dried ferns, grasses, twigs, plant cuttings, or lace to use as stencils
pencil

Place a baking sheet in the center of the oven and preheat the oven to 350°F.

Combine the methyl cellulose with 1 cup cool water. Let stand 3 to 4 hours, stirring occasionally. The mixture will thicken into a translucent, gelatinous paste.

Put 1 teaspoon of the methyl-cellulose mixture in the empty bottle of the spray gun, fill the bottle two-thirds full of lemon juice, and shake to combine. The lemon juice mixture will have a little body, about as thick as whole milk.

With the masking tape, mask out a margin all around the edges of a rectangle of paper, so that the outside edge of the masking tape is flush with the outside edge of the paper; do not tape the paper to the work surface. Choose an object from among your natural materials and place it on the paper. If you are using an object that has a wide surface, like a leaf, use small pieces of masking tape, rolled sticky-side out into cylinders on the back of the object, to secure it to the paper. If you are using delicate grasses or weeds, tape the objects to the masking-tape border rather than your work surface, so that you can set the whole assembly aside to

dry before removing the stencils and tape from the samples. (The masked-out margin also makes a beautiful edge when removed.) Whatever taping method you use, make sure nothing slips or moves while you are spraying, or your image will be blurry.

Using the spray gun, spray thickened lemon juice across the stencil onto the paper. Spray lightly and evenly in a single application, holding the gun at a consistent angle as you do—you must be sure not to change the angle or spray under the stencil where it stands away from the paper. Repeat to make additional samples, choosing stencils from among your other materials.

Leave the objects taped on and let the lemon juice dry thoroughly before removing the objects and tape. Make a tiny pencil mark in a corner of the paper to indicate the "juice side."

Bake as you did in the previous exercise (pages 90–92). The baking time will be slightly longer in the oven because the thickened lemon juice browns more slowly—approximately 60 seconds or slightly more.

Sprayed lemon juice thickened
with methyl cellulose, dried flower
as stencil, baked to reveal

Sprayed lemon juice thickened with methyl cellulose, bare branch as stencil, baked to reveal image

MAKE YOUR MARK

ANTIQUE DOCUMENTS

If you want the whole piece of paper to look antique, like a treasure map or an old photograph, skip the tape and spray all the way to the edges of the paper. You can even spray the back to make the whole paper look old, if the picture is to be a part of an artwork that is handled, such as in a book or box of collected images.

Sprayed lemon juice thickened with methyl cellulose, pine branch as stencil, baked to reveal image

MAGICAL WRITING

What better way to use invisible ink than making a page of magical writing? During the Second World War, lemon juice and milk were used to literally write between the lines on a postcard. The postcard could be held over a heat source and the secret writing would darken to reveal messages that might not have made it past the censors. You can simply write with a quill pen dipped in lemon juice or, as in this exercise inspired by Leonardo da Vinci's backwards writing, you can create a stencil by enlarging a sample of your own writing. This stencil is a novel way to add text and a layer of meaning to an artwork, or to make an interesting background texture to set off another image.

YOU WILL NEED:
thick black felt-tip pen
masking tape
one 12-by-12-inch piece .004 ml matte Mylar
 or clear acetate
pencil (or ballpoint pen if you are using clear
 acetate)
self-healing cutting mat or smooth cardboard
X-acto knife with no. 11 blades
baking sheet
1 teaspoon methyl-cellulose powder
Preval spray gun
1 cup bottled lemon juice, strained
2 approximately 7-by-10-inch rectangles of
 medium to heavyweight white paper

Use the pen to write something in cursive, your name perhaps, leaving more room between letters than you would ordinarily. Take this writing sample to a copy shop and enlarge it so that the letters are about 2 inches high.

Tape the enlarged writing sample to a window with the printed side facing the window. Tape the Mylar over this and trace the writing with the pencil. Put the Mylar tracing on the self-healing cutting mat and use the X-acto knife to cut along the lines. On letters with holes in them, such as R or O, you will have to leave a connecting tab of Mylar, or "stencil bridge" to hold in the center (see page 29).

Place a baking sheet in the center of the oven and preheat the oven to 350°F.

Combine the methyl cellulose with 1 cup of cool water. Let stand for 15 minutes, stirring occasionally. The mixture will thicken into a translucent, gelatinous paste.

Put 1 teaspoon of the methyl-cellulose mixture in the empty bottle of the spray gun, fill the bottle two-thirds full of lemon juice, and shake to combine. The lemon juice mixture will have a little body, about as thick as whole milk.

Place the stencil on a rectangle of paper. Using the spray gun, spray thickened lemon juice across the stencil onto the paper. Let dry, remove the stencil, and bake as you did for the project on pages 90–92. It will take slightly longer in the oven because the thickened lemon juice browns more slowly—approximately 60 seconds or slightly more. Repeat with the second piece of paper.

Sprayed lemon juice thickened with methyl cellulose,
Leonardo da Vinci backwards-writing stencil, baked to reveal image

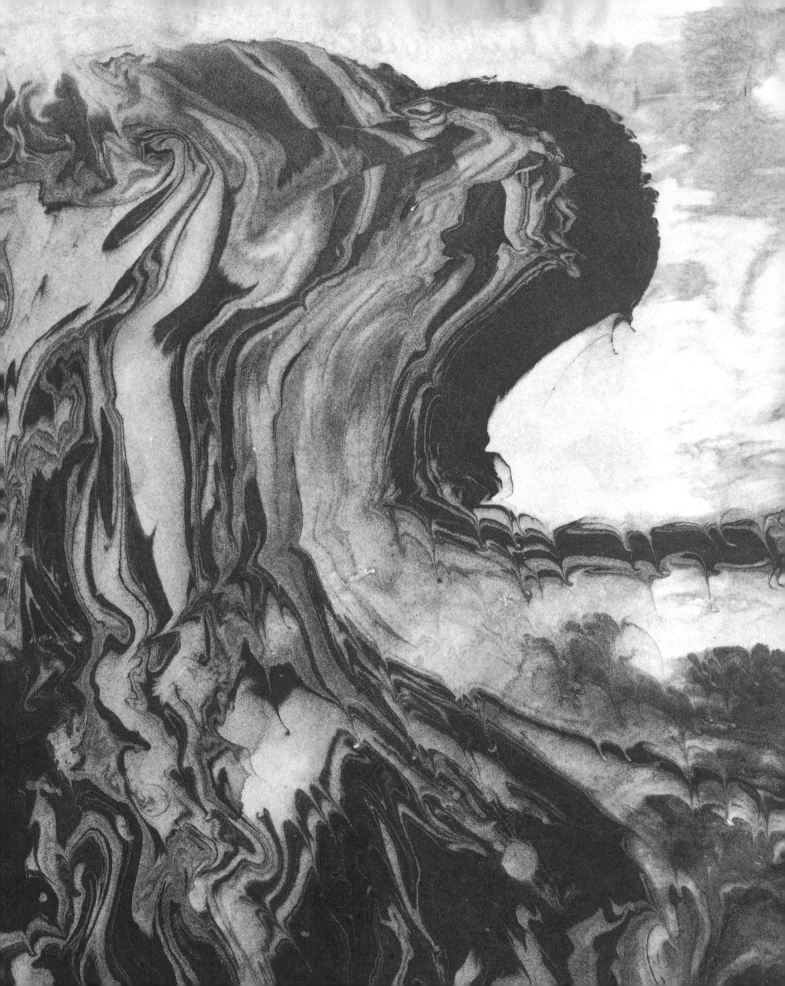

WATER PRINTING

Marbling is the art of swirling pigmented media on the surface of water and lifting an impression of the swirls with a piece of dry paper. The first known form of marbling is the centuries-old Japanese method called *suminagashi*. In *suminagashi*, a monk would sit beside a pool of water, and when the pool was absolutely still, he would drop sumi ink onto the surface of the water. The water had to be perfectly calm so that the surface tension of the water would prevent the ink from sinking. The monk would fan the water or blow at the ink through a reed to create swirls in the surface of the ink. The results of this technique are enchanting: uneven swirls, isolated arabesques, and amorphous white bubbles in the middle of swirling texture, like an archipelago in the sea.

Another traditional marbling technique, called *ebru*, originated in Turkey. In this technique, a medium that doesn't mix with water, such as oil-based paint or ink, is thinned with oil or turpentine, then dropped into a shallow tray filled with water. The oil color floats on the surface of the water. Sometimes the water is thickened slightly to aid the flotation of the pigment. In Europe, the paper to be marbled by the *ebru* method was first soaked in water and aluminum sulfate, or alum, and dried before laying it on the water to absorb the swirls of oil color.

In this brief chapter, you will find instructions for water printing, a hybrid marbling technique inspired by the marbling traditions that came before it. With this technique alone, you can explore the endless variety of the marbleized mark. You'll find that some marbleized papers resemble familiar topographical maps, while others look like the landscape of a faraway planet.

opposite
Marbling on paper, india ink combined with a photographic wetting agent

WATER PRINTING

In this exercise, india ink is combined with a photographic wetting agent and floated atop a mixture of methyl cellulose and water. Kodak Photo-Flo is found in photography stores that sell photo-developing supplies; eye droppers are available at drug stores. Rice paper will make a more diffuse marbled mark, and high-rag-content stationery will make a sharper, crisper image. Try both, and experiment with any other scraps of paper you might have around to see what happens.

Marbling on paper, india ink combined with a photographic wetting agent, swirled with a wooden skewer

plastic drop cloth

clean, empty 1-gallon plastic jug (plastic milk jugs work well)

5 tablespoons methyl-cellulose powder (see page 94)

plastic washtub or similarly sized plastic tray that you don't ever intend to use for dishes

protective gloves

2 eyedroppers

Kodak Photo-Flo 200 wetting agent

2 small clean, wide-mouthed plastic containers with lids (8-oz. yogurt or cottage cheese containers work well)

waterproof india ink

metal whisk

wooden or metal skewers, or chopsticks

3 to 4 sheets rice paper such as Okawara or Mulberry, torn into rectangles approximately 10 by 11 inches, or high-rag-content stationery or lightweight printmaking paper

paper towels (optional)

Cover a protected area of your work space with the plastic drop cloth, for drying samples, as they will be particularly juicy.

Fill the plastic jug halfway with warm water. Add the methyl cellulose, secure the lid, and shake well. Let stand for at least 2 hours, shaking occasionally, to make sure that all the methyl-cellulose granules have dissolved and the mixture is uniformly gelatinous.

Fill the washtub with 1 inch of water and place the tub on a protected work surface.

Put on the gloves. Using an eyedropper, combine 3 drops of Photo-Flo with ⅓ cup water in one of the plastic containers. In the second plastic container, combine 3 tablespoons india ink with 3 drops Photo-Flo.

continued

Pour half of the methyl-cellulose mixture into the tub of water and whisk to combine. The ideal consistency for the mixture in the tray is like that of heavy cream. If it is too thick, add more water; if it is too thin, add more of the methyl-cellulose mixture.

Rinse out the eyedropper and use it to add a few drops of the india-ink mixture to the tub. It should float and spread in small pools on the surface of the liquid, although it's okay if a little bit sinks. With a skewer, gently pull the small ink pools apart into swirls.

Holding a piece of paper by the edges, lay it on the surface of the liquid, touching the middle of the paper to the surface first and settling down the edges carefully. The impression happens instantly; lift the paper right away and set aside face-up to dry. If you are using high-rag-content stationery, it will curl back from the water quickly: Make sure the paper doesn't curl onto itself.

Because the methyl cellulose is an adhesive, make sure that the papers you have marbleized do not touch one another on the drying surface, as they will stick together.

Add a few more drops of ink to the tub. Use the second eyedropper to add a few drops of the water–Photo-Flo mixture in the middle of the ink drops. The clear drops should push the ink aside, making clear pools in the centers of the ink pools. Take your water prints from these big circles, or draw the skewer through them first to make swirls.

The more you draw the skewer through the ink on the surface of the liquid, the more detailed your marbling will be. The less you swirl the ink, the larger and more dramatic the marbling will be on the page. Try a variety of dropping and swirling techniques.

As you use the tub of methyl-cellulose mixture, the background color of your water prints will become increasingly gray. If your background color is becoming too gray for your liking, and you want a clearer, sharper demarcation between light and dark, empty the tray, wipe it out with paper towels, and refill with the methyl-cellulose mixture as before.

Marbling on paper, india ink with a photographic wetting agent dropped to make large circles

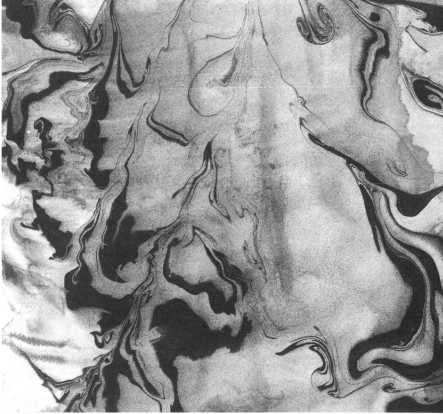

Marbling on paper,
india ink combined with a
photographic wetting agent,
swirled with a wooden skewer

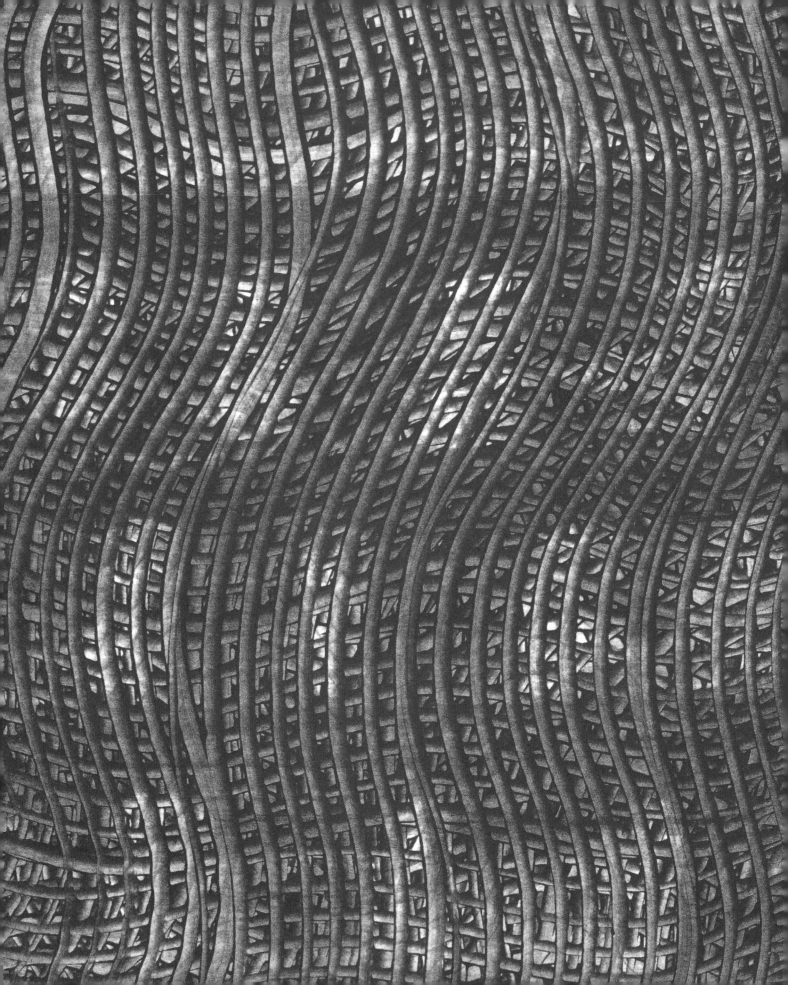

CHAPTER 8
PASTE PAPERS

Paste papers began to appear on book covers and endpapers in the late sixteenth century. In this technique, pigment, in the form of acrylic paint, watercolors, or gouache, is added to cooked paste made with wheat or rice starch to make a wonderfully sensuous paste paint. The mixture is painted on a piece of paper, and cardboard combs are drawn through it to create intricate patterns, swoops, and swirls and a sense of woven layers, the hallmarks of paste papers.

The ease of making paste papers and the seductiveness of this technique make it difficult to stop at making just one. It is much like the finger painting you may have done as a child. The end results can be used as decorative papers for lining and covering boxes, wrapping gifts, or even as wallpaper. Paste papers can be used in collage, both in combination with other materials or by themselves, cut into an elaborate-looking inlay. One paste paint color makes an elegant paper, and more than one can add a richness or illusion of depth within the page. Try using iridescent and metallic paints for the paste paint; the sparkle adds another layer of detail.

opposite
Wheat paste and acrylic paint on paper, combed into a basket pattern

WHEAT PASTE

Here is a basic recipe for making a paste of wheat starch and water. Wheat starch is available from bookbinding suppliers or some art supply stores that sell bookbinding materials. After the paste is made, it will not last more than 2 or 3 days, but the starch will store almost indefinitely at room temperature in its powder form. Buy the smallest amount you can; a little goes a long way. Rice starch also makes a good paste; substitute an equal amount.

Wheat paste and acrylic paint on paper, combed into a lattice

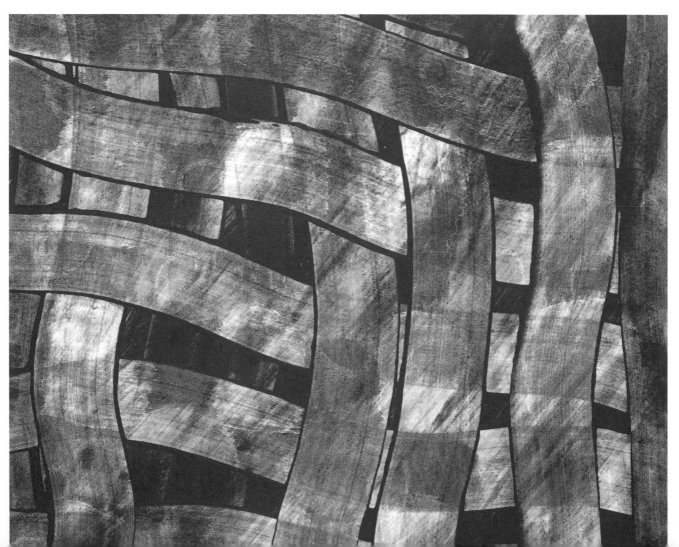

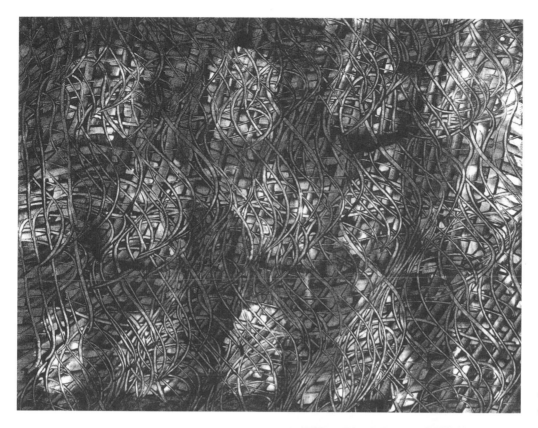

Wheat paste and acrylic paint on paper, intricately combed

YOU WILL NEED:
3 tablespoons wheat or rice starch
metal whisk
2 cups boiling water, plus more if needed
1-quart metal or heat-resistant glass bowl

In a saucepan, combine the wheat starch with ½ cup cold water and whisk until well mixed. Add the 2 cups boiling water and bring the mixture to a boil over high heat, stirring constantly. You want the mixture to have the consistency of yogurt; add more boiling water if the mixture gets too thick.

Remove from the heat, transfer to the bowl, and set aside to cool. Stir the paste once or twice while it cools to prevent a skin from forming on top. The mixture will thicken a little as it cools, but you can add cool water to thin it when ready to use.

PASTE PAPERS

The 2 cups wheat paste for this exercise is enough to paint about 20 samples, so buy paper accordingly. The paper you use must have some "wet strength," as you will be working and reworking the surface; ask for assistance when purchasing the paper.

Wheat paste and acrylic paint
on paper, pattern made with
different sized combs

YOU WILL NEED:

2 cups wheat paste (page 108)
4 clean, wide-mouthed plastic containers with
 lids (yogurt or cottage cheese containers
 work well)
black acrylic paint
white acrylic paint
yellow ochre acrylic paint
stir sticks (craft sticks, tongue depressors,
 plastic spoons, or chopsticks)
scissors
scraps of lightweight cardboard
3 to 4 sheets lightweight to medium-weight
 printmaking paper, torn into rectangles
 approximately 10 by 11 inches
four 1-inch chip brushes
plastic cup (optional)
pencil with eraser (optional)
foil (optional)

Wheat paste and acrylic paint on paper, pattern made with combing and a twisted plastic cap

Put ½ cup paste in each of the 4 containers. Add 1 teaspoon black acrylic to one (to make a very transparent black), 1 tablespoon black acrylic to another (to make a darker black), 1 tablespoon white acrylic to the third, and 1 tablespoon yellow ochre to the fourth. Combine all the paste and paint mixtures well using stir sticks.

With the scissors, cut the scrap cardboard into three to four 4-inch squares. (You'll want to make more as you experiment.) Cut teeth into the pieces, creating combs out of each square. Vary the size and shape of the teeth, making some sharp and pointy and others blunt and square.

Put the rectangles of paper in a stack next to your work surface. Using a chip brush, paint a piece of paper all over with the transparent black paste. Comb through this with one of the cardboard combs. What do you see? Comb in one direction and then perpendicularly across the lines you just made. Leave it as is or comb it some more, in other directions. If you don't like what you have done, brush more paste paint on top and try again.

Working through your stack of clean paper, experiment freely. You can comb a plaid pattern, stripes, waves, or various-sized swirls. Try dabbing black all over another piece of paper, then dabbing white in the spaces left over. Draw combs through this. Do the same with the black and ochre paste. Using those same color combinations, paint stripes on paper before combing. You will be able to see the stripes subtly in the background through the combed texture.

continued

Using a 1-inch-wide scrap of cardboard, try making a lattice pattern or a large stripe. To create an illusion of depth or layers, make a smaller comb texture all over a page, and then pull the 1-inch piece of cardboard through this.

Paint the ochre paste on a clean piece of paper and scrape most of it off. It will leave a stain on the paper. Now apply black and comb a texture or pattern in this to see the yellow underneath.

Other ideas for making patterns: Twist a plastic cup into painted paste, dab off dots with a pencil eraser, twist a piece of crumpled foil into the paste. Finger paint!

Wheat paste and acrylic paint on paper, intricately combed

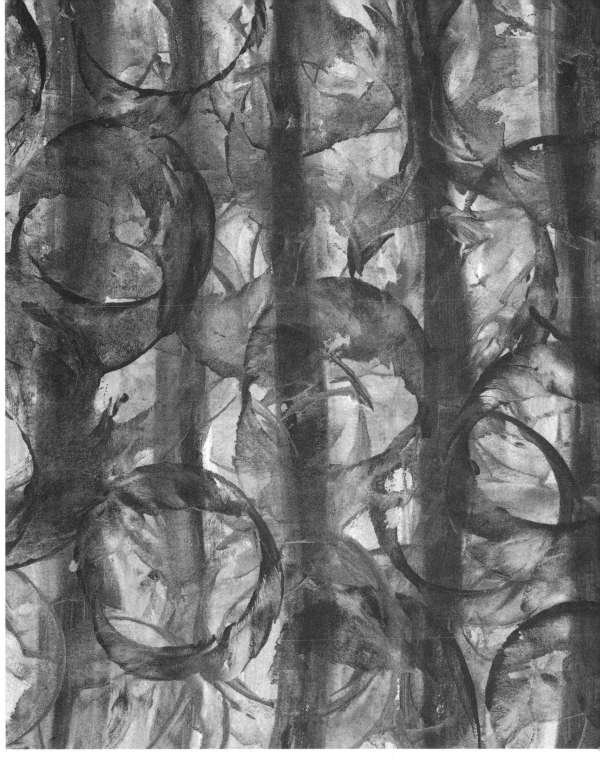

Wheat paste and acrylic paint on paper, pattern made by twisting the rim of a plastic cup in the paste mixture

CHAPTER 9
PATTERN DYEING

Have you ever tie-dyed a T-shirt? You probably pulled points up in the fabric, secured them with rubber bands, and immersed the T-shirt in dye to get bold sunburst patterns where the rubber bands kept the dye from absorbing into the fabric.

Tie-dying comes from *shibori*, the Japanese art of pattern dyeing, a technique that has been used to dye sumptuous kimono fabrics for hundreds of years. *Shibori* offers a wide variety of techniques for achieving different patterns on fabric, including plaids, stripes, wood grain, and dotted texture.

In this chapter, some of the *shibori* techniques are adapted for dyeing paper. Some of the stitching and tying techniques appropriate for fabrics are damaging to paper, but a medium-weight rice paper is strong enough to be folded, wrinkled, twisted, and immersed in hot dye. The high degree of sizing in Western papers resists dye, so while dye would make some interesting marks on these papers, it probably won't penetrate through all the layers, in the case of a pleated and dyed sample, for example. *Shibori* is a magical mark-making technique. There are always surprises when you open a tied, pleated, or clamped dyed paper. There are things about the process that cannot be controlled, and this makes for some wonderful "accidents." These papers can be used as endpapers in a book, as wrapping paper, stationery, or the base for a print, or displayed as a series of works in and of themselves.

opposite
Pleated and dyed rice paper

In this chapter you will find techniques for pleating and dyeing paper to make stripes and plaids; crumpling, twisting, and dyeing paper to make sunbursts and textures; and folding and clamping paper with symmetrical clamps to make repeat patterns.

Liquid household dye, such as Rit dye, is readily available in most large grocery or housewares stores. Buy it in liquid form, as the powdered dye is hazardous to breathe. If you love this technique and find yourself doing a lot of it, you may wish to explore other liquid dyes such as Createx liquid fiber-reactive dyes (see Suppliers, page 162).

PLEATING & FOLDING: STRIPES & PLAIDS

Using the technique in this exercise, you can make as many different dyed stripes and plaids as you can think of ways to fold the rice paper. Pleating paper like an accordion or fan creates stripes. For a plaid, you simply pleat, dye, unpleat, and then pleat again, perpendicular to the first stripes, before immersing in dye again. You can make regular and irregular pleats, neat ones and rumpled ones. You will not get the same result twice!

YOU WILL NEED:

plastic drop cloth

1 sheet medium-weight rice paper such as Mulberry, student-grade Okawara, or Kitakata, torn into squares approximately 12 by 12 inches

paper clips

protective gloves

3 large plastic buckets (at least 2-quart capacity)

black liquid household dye such as Rit (see page 115)

paper towels

Cover a large, flat area of your work space with the plastic drop cloth, for drying the samples.

Pleat a piece of rice paper as shown in the illustration.

You can make bigger or smaller pleats than the illustration indicates, as long as the pleats are approximately uniform in size. Smooth the folds of the pleats together and secure as shown with paper clips. If your pleats are wider than the ones shown, you may need additional paper clips.

Put on the gloves. Fill 2 of the buckets with 2 quarts hot water each. Add approximately 3 tablespoons dye to one of the buckets and stir to combine. Fill the third bucket with cold water for a rinsing bath.

Immerse the pleated and paper-clipped paper in the clean hot water and soak for 1 minute. Transfer the wet paper to the dye bath and let it soak for a few minutes, or until it reaches the desired value. (While this piece is soaking, you can fold another piece to dye.)

Remove the paper from the dye bath and rinse in the cold water. Press dry between paper towels. Carefully remove the paper clips. You may have to unbend them slightly, as they can tear the paper if you slide them off the way you put them on. Unfold the pleats and gently smooth the paper flat on the drop cloth–covered surface to dry. Repeat to make additional samples.

Pleated and dyed rice paper

Uneven pleating, dye on rice paper

STRING-TIED PLEATS

Pleat a piece of rice paper as shown in the illustration. You can make bigger or smaller pleats than the illustration indicates, as long as the pleats are approximately uniform in size. Smooth the folds of the pleats together, fold again as illustrated, and tie firmly with string. Dye as directed on page 116.

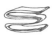

String-tied pleats, dye on rice paper

CLOTHESPINNED PLEATS

Pleat a piece of rice paper as shown in the illustration. You can make bigger or smaller pleats than the illustration indicates, as long as the pleats are approximately uniform in size. Smooth the folds of the pleats together, fold again as illustrated, and clamp with a clothespin. Dye as directed on page 116. Because the clothespin is buoyant, you may have to put a weight on it to hold it under the surface of the dye.

Clothespinned pleats, dye on rice paper

VARIEGATED PLEATING

Rather than neatly pleating the paper, gather it up in your hands like gathering curtains beside a window. Crumple this together into one long piece, and either fold it on itself a few times or roll it into a tight coil, and secure with string. Dye as directed on page 116.

Variegated, or crumple-pleating, dye on rice paper

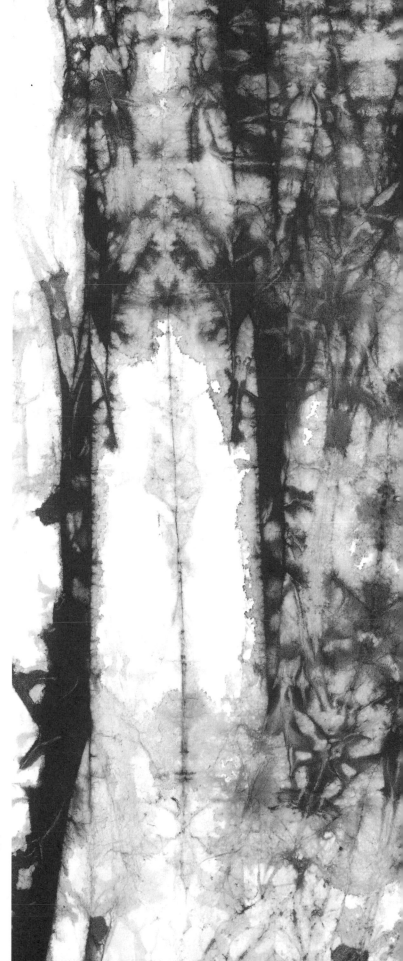

DYEING TIPS

- *To ensure a crisp distinction between dark and light areas when pattern dyeing, soak the clamped or tied paper in clean, hot water before dyeing. The water soaks into the clamped areas and acts as a further resist to the dye. (If you omit the soaking step, you will get a fuzzier, more indistinct pattern, which can also be desirable.)*
- *Use hot water for the clean soak so that you won't lower the temperature of the dye bath.*
- *The paper looks about twice as dark in the dye bath as it will be when dry.*
- *Rinse dyed paper in cold water after dyeing.*

Variegated, or crumple-pleating, dye on rice paper

TIE-DYEING: SUNBURSTS

You can twist and tie rice paper in the same way that you would twist and tie a T-shirt. The rice paper is very durable and can hold up to much stress. With this technique, you can make an all-over, marblelike texture; bold sunbursts; or a wood-grain pattern.

YOU WILL NEED:
plastic drop cloth
2 to 3 sheets medium-weight rice paper such as Mulberry, Okawara, or Kitakata, torn into squares approximately 12 by 12 inches
string or rubber bands
protective gloves
3 large plastic buckets (at least 2-quart capacity)
black liquid household dye such as Rit (see page 115)
paper towels

Cover a large, flat area of your work space with the plastic drop cloth, for drying the samples.

To make a single sunburst, pull up a piece of paper from a point in the middle, as shown in the illustration at left. Wind string along the length of the sunburst point. To make multiple sunbursts on the same piece, pull up as many points as you wish, and tie each point separately with string.

Put on the gloves. Fill 2 of the buckets with 2 quarts hot water each. Add 3 tablespoons dye to one of the buckets and stir to combine. Fill the third bucket with cold water for a rinsing bath.

Immerse the tied paper in the clean hot water and soak for 1 minute. Transfer the wet paper to the dye bath and let it soak for a few minutes, or until it reaches the desired value. (While this piece is soaking, you can tie another piece to dye.)

Remove the paper from the dye bath and rinse in the cold water. Press dry between paper towels. Snip the string with scissors and gently smooth the paper flat on the drop cloth to dry. Repeat to make additional samples.

VARIATION: TIE-DYEING
SIMPLE CRUMPLE

Crumple a piece of rice paper tightly into a ball and tie it with string to hold it together in the dye bath. Dye as directed above on page 116.

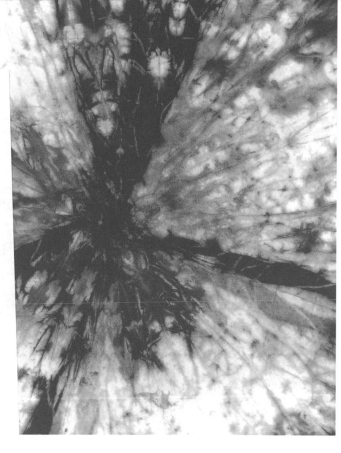

Single sunburst on rice paper,
one peak tied and dyed

nbursts, many peaks tied and dyed

Simple crumple, dye on rice paper

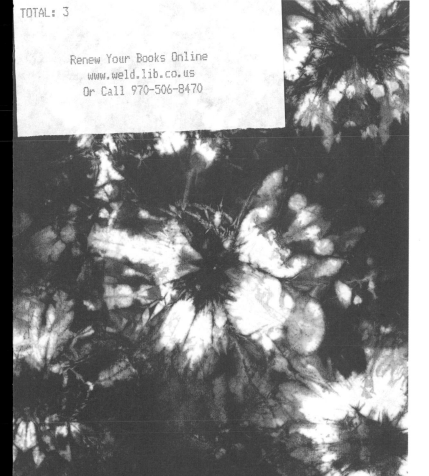

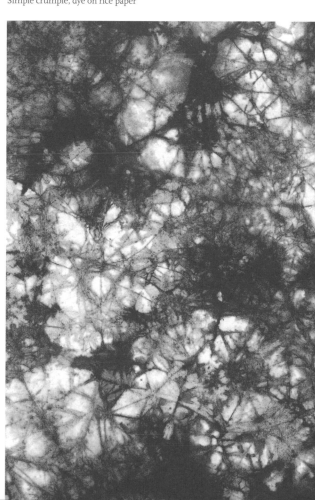

CLAMP DYEING: REPEATED MOTIFS

If you fold a piece of rice paper, pinch the folded paper tightly with your gloved thumb and index finger, and dip it into warm dye, when you unfold the paper, you'll see whitish spots where your digits clamped the paper together. You can use the same principle to clamp and dye patterns onto paper. Instead of fingers, this exercise employs plastic shapes to create specific patterns. Using a plastic cutter (a mat-knife-like tool for cutting plastic) and rigid sheets of plastic, you can create a variety of shapes to use for clamping the paper (cut the plastic on smooth cardboard rather than a self-healing cutting mat, as the plastic cutter will scar the surface). The patterns are surprising for their preciseness, and delightful in the beautiful washy areas that are not so precise. You can make pages covered all over with a pattern or leave large white voids in the midst of a pattern that lend themselves to the addition of written text or collaged or printed imagery.

YOU WILL NEED:
plastic drop cloth
heavy-duty plastic cutter such as the Olfa
 P-800 (see page 129)
one 8-by-10-inch sheet of ¹⁄₁₆-inch plastic
large piece of smooth cardboard
2 to 3 sheets medium-weight rice paper such
 as Mulberry, Okawara, or Kitakata, torn
 into squares approximately 12 by 12 inches
one 4-inch C-clamp
protective gloves
3 large plastic buckets (at least 2-quart
 capacity)
black liquid household dye such as Rit
 (see page 115)
paper towels

Cover a large, flat area of your work space with the plastic drop cloth, for drying the samples.

To create an all-over pattern with squares, first cut 2 identical plastic squares using the plastic cutter: Place the plastic sheet on the cardboard and use the cutter to score two 3-inch squares. Break the plastic along the score lines and peel off the plastic's outer film.

Pleat a piece of rice paper, making the pleats a little wider than the plastic squares. Fold the pleated paper on itself as shown in the illustration, making the folds as wide as the pleats.

Squeeze the pleated and folded paper between the two squares of plastic like a sandwich, lining the squares up with each other. Clamp the plastic-and-paper-sandwich with the C-clamp.

Clamp dyeing, with plastic squares and C-clamp, on rice paper

Put on the gloves. Fill 2 of the buckets with 2 quarts hot water each. Add 3 tablespoons dye to one of the buckets and stir to combine. Fill the third bucket with cold water for a rinsing bath.

Immerse the pleated and clamped paper in the clean hot water and soak for 1 minute. Transfer the wet paper to the dye bath and let it soak for a few minutes, or until it reaches the desired value. (While this piece is soaking, you can fold another piece to dye.)

Remove the clamped paper from the dye bath and rinse in the cold water. Remove the clamp and plastic squares and press the folded paper dry between paper towels. Unfold the pleats and gently smooth the paper flat on the drop cloth to dry. Repeat to make additional samples.

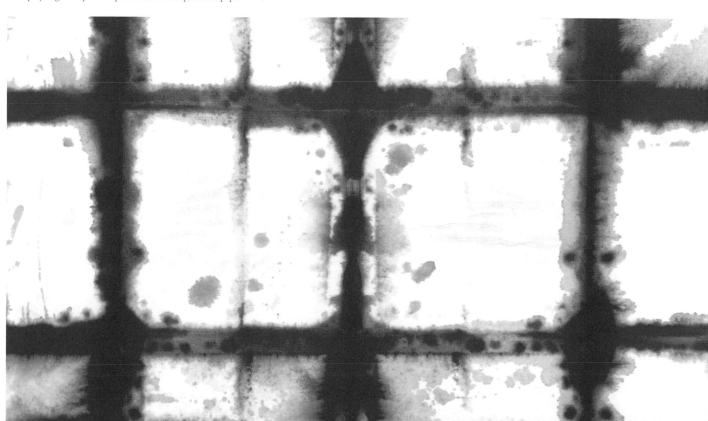

CLAMPING TRIANGLES & CIRCLES

You can make pattern variations by cutting pairs of any shape from the plastic and clamping them as you did the squares. It is not possible to cut identical circles with a plastic scoring knife, so use found circles as clamps: pairs of caps, lids, or coins, for example.

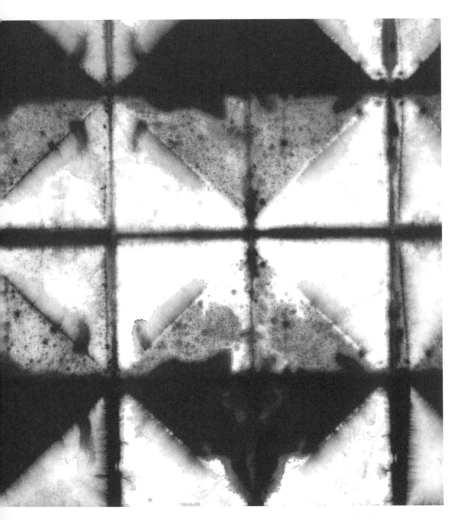

Clamp dyeing, with plastic triangles and C-clamp, on rice paper

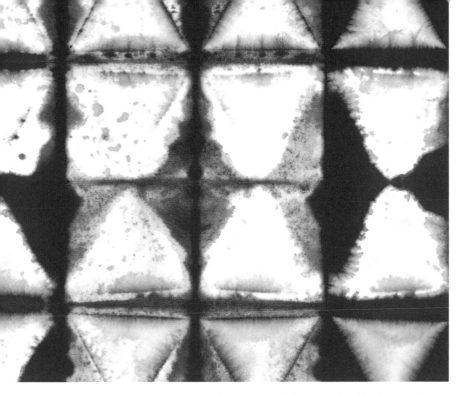

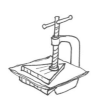

Clamp dyeing, with plastic triangles and C-clamp, on rice paper

Clamp dyeing, with round plastic caps and C-clamp, on rice paper

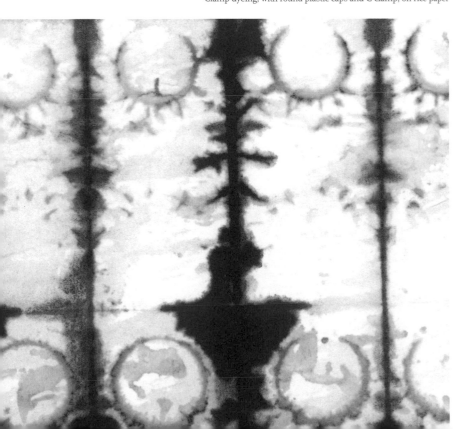

CLAMPING ORNATE SHAPES

If you have access to a jigsaw, you can cut a variety of ornate shapes to clamp and dye. Almost anything that has a clear silhouette will work, but you will need the silhouette to be simple enough for the jigsaw to follow, making sure that there is room for the blade to turn around in interior curves. If you have a shape you like with a couple of tricky spots, just simplify those problematic areas on the outline. The image on this page was created using the pattern on page 160.

To cut 2 identical pieces, trace or draw the desired shape onto paper. Peel the plastic film off of 2 same-sized pieces of plastic and sandwich your drawing in between the two pieces. Tape the pieces together in a few places around the edges and cut along the lines of your drawing with the jigsaw. Wear respiratory protection as you cut, as the saw will throw off plastic dust and the hot plastic gives off fumes. Do not push too hard or the friction will make the plastic melt and gum up the blade. As you progress, you will cut away the

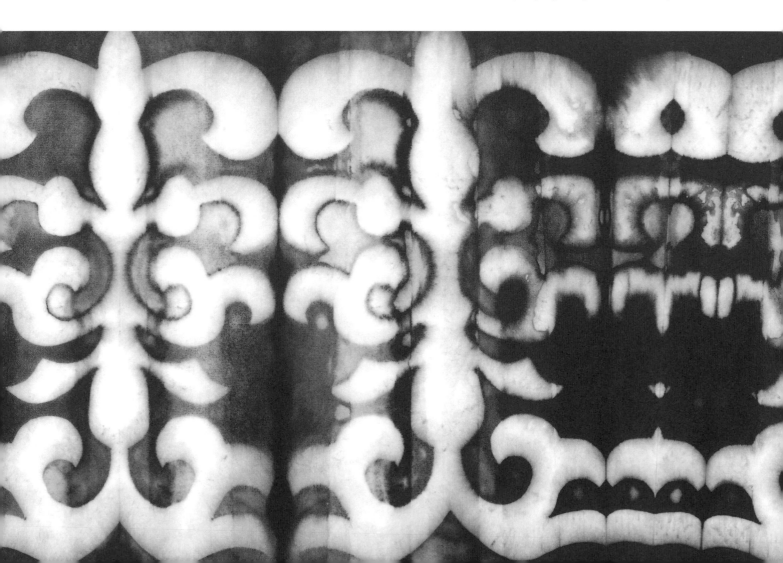

masking tape holding the 2 pieces together, so you should stop as needed to re-tape where you have already cut. When you are finished cutting, you may have to sand the little burr that sometimes occurs on the edge of plastic cut in this manner. Use your ornate-shape clamps in the same way that you used the square clamps for the project on page 124. You can also clamp them on irregular pleats or use only an edge of the shape. Any way you can devise to fold or pleat the paper to clamp will give you a different result.

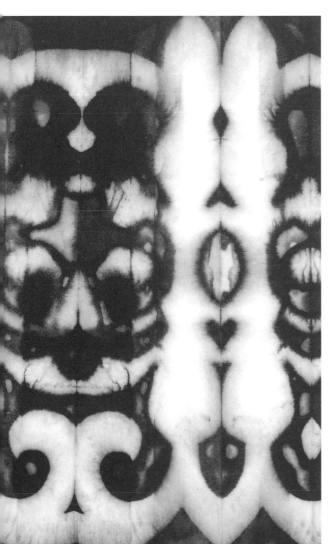

Clamp dyeing, with ornate shape and C-clamps, on rice paper

> ### TOOL TIP: USING THE OLFA P-CUTTER OR OTHER PLASTIC-CUTTING KNIFE
>
> When you buy plastic, it will often come covered with a lightweight film on both sides to protect the plastic from scratches. Leave this on during the cutting process, as it gives you a place to mark on the plastic as well as protecting it. The plastic cutter is a sharp scoring device. To make a "cut," you score along a straightedge several times, then break the plastic along the score line.
>
> Using a ballpoint pen, make 2 marks on the plastic film to describe 2 points on the line you wish to cut. Lay the plastic on a piece of cardboard with the end of the cardboard positioned a little off the edge of your work surface. (This is to ensure that you don't gouge your table if the cutter goes off the edge of the cardboard.) Place a metal (preferably steel, as the cutter can damage aluminum) straightedge along your marked line.
>
> Hold the straightedge in place with one hand while you draw the cutter firmly along the edge with the other hand to score the plastic, always toward the edge of your work surface. For the $^1/_{16}$-inch plastic called for in this chapter, you will need to score the plastic 4 or 5 times along the same line. For thicker plastic, you will need to score more. Remove the straightedge. Line up the scored line along the sharp edge of a table, scored-side up. Hold the plastic flat against the table and apply pressure firmly to the part hanging off the edge of the table. The plastic will snap cleanly along the score line.
>
> It is very difficult to score and snap off a strip that is very narrow. Often it will not snap cleanly, leaving lots of jagged pieces. Keep this in mind when planning how to cut the plastic for this chapter's clamp-dying exercises.

CHAPTER 10
COLLAGE

In our hectic, media-saturated world, collage is an apt way to express your-self. Collage is a great way to pull together disparate visual ideas, incorporate text into your artwork, and use images from daily life such as print media, photographs, or wrapping paper. The beauty of collage is that it requires no drawing skills. But, even if you are using found materials, the way you cut and combine them is distinctly your own.

Collage materials are all around us. Antique papers such as old newspapers, magazines, deeds, letters, stamps, and maps make wonderful material for collage. Not only are these papers visually interesting, but they are often made from cotton rag, and so are acid free, flexible, and durable. You can find antique papers at flea markets, auctions, antique stores, used book stores, or your own attic. Old photographs are interesting additions to collages—at flea markets, you will often see stacks of photographs of unidentified people and places. (If you wish to use old photos from your personal archives, make duplicates to collage, and save the originals for posterity.) Collecting materials for collage art can become an enjoyable pastime. Keep a folder filled with your finds.

You must have a sturdy base to build your collages on, such as a heavy print-making paper, acid-free illustration board, or other stiff board or paper. You will be using a combination of polyvinyl acetate and methyl cellulose to glue your collages together.

In this chapter, you will find a method for efficiently assembling a collage, and a variety of ideas for generating collages. This technique was placed near the end of the book for a reason: if you have worked with the other chapters, by now you likely have samples from the exercises that you can incorporate into collages. The addition of marbleized, stenciled, printed, dyed, or painted papers can contribute a variety of textures to make your collages sing.

opposite
Collage of found papers
on a sample from the
"Gouache Resist" chapter

THE BEST COLLAGE ADHESIVE

Polyvinyl acetate, commonly called PVA, combined with prepared methyl cellulose in a 1 to 1 ratio is the ideal marriage for collage purposes. Methyl cellulose alone is not sticky enough to adhere materials to your base paper or board, while the polyvinyl acetate is very sticky and dries too quickly to be used by itself in collage art. PVA is available in art supply stores, and sometimes stationery stores that carry supplies for scrapbooking. The methyl cellulose–PVA adhesive cleans up with soap and warm water when wet, but is impervious to water when dry. It will keep, covered, for 2 to 3 months at room temperature.

YOU WILL NEED:
2 clean, wide-mouthed plastic containers with
 lids (yogurt or cottage cheese containers
 work well)
1 tablespoon methyl-cellulose powder (see
 page 94)
polyvinyl acetate (see above)

In one of the plastic containers, combine the methyl cellulose with 1 cup cold water. Let stand for a few minutes, then stir again. Let this mixture stand 3 to 4 hours, covered, until it becomes translucent and gelatinous.

In the second plastic container, mix 1 part methyl-cellulose mixture to 1 part PVA. This makes a good adhesive for most collage materials. If you are adhering a very heavy or stiff paper to a collage, you may need to add more PVA to the mixture. If your papers are all thin and delicate, you may wish to add more methyl cellulose to the mixture.

BASIC COLLAGE

Before beginning a collage, you may wish to paint a wash of ink and water over your white base paper and let it dry. It can be hard to make the solid white paper "settle down" visually when combined with the various subtle textures of your found papers. You can also use a sample exercise from another chapter in this book as a base for a collage. This exercise calls for an old magazine or catalog as a work surface. After you apply your glue to your cutout, you can turn to a fresh page and begin on your next cutout atop a clean work surface.

YOU WILL NEED:

collage materials (see page 131)
scissors or X-acto knife with no. 11 blades
old magazine or catalog (to use as a work
 surface)
small glue brush (an acrylic painting brush
 with soft bristles about ½-inch wide)
collage adhesive (facing page)
1 sheet heavyweight white or cream-colored
 paper, torn into rectangles approximately
 7 by 10 inches, or acid-free illustration
 board or museum board cut into similar
 sizes
a few sheets of clean, blank newsprint
bone folder
spray bottle filled with water (optional)
waxed paper (optional)
paper towels (optional)

Trim any collage materials as desired with the scissors or X-acto knife.

Select a piece for your collage and place it back-side up on the magazine. Use the brush to apply adhesive to the backside of your collage material, always brushing from the middle of the piece you are gluing to the outer edges.

Position the collage material glue-side down as desired on the heavyweight paper or board. Put a clean sheet of newsprint over it and gently burnish the object down with the flat side of your bone folder (this pushes out any bubbles trapped under the paper and makes a smooth, flat bond). Peel the newsprint away and discard. Repeat as desired, building your collage.

As the moisture from the glue can cause the paper or board to buckle and warp, you may want to flatten your collage under weights, such as a board with bricks on top or a stack of heavy books. For best results, you want to flatten your collage when damp; but rather than putting the still-wet collage under weights and risk having the glue squish out in an unsightly way, wait for the collage to dry completely, then lightly mist the back of the collage with water. Put a sheet of waxed paper on a flat surface, then a piece of clean newsprint or a paper towel on top of that, then your damp collage. Place another sheet of clean newsprint or paper towel over the collage, then another sheet of wax paper, then weights. The waxed paper protects the weights (if you are using books) from the moisture of the collage. The paper towels absorb some of the moisture to help speed drying time. You can put multiple collages in this weight sandwich, putting paper towels or clean newsprint between each collage. Let the collages dry under weights overnight.

INCONGRUITY

Collage allows you to put seemingly contradictory things together: a woman standing on a huge orange, an automobile in an etching of preindustrial London, a modern businessman at a medieval tournament. These paradoxical pairings delight and fire the imagination, and lead to stranger and more wonderful combinations. Look through your collected collage materials and seek out some contradictory images. Combine these images in a way that pleases you, without adhesives, on a piece of heavyweight paper or board. When you are satisfied with your composition, glue the pieces on one by one as directed on page 133.

Collage of figures and interior space from antique newspapers

Collage of figure and landscape from antique newspaper, on a sample from the "Gouache Resist" chapter

COLLAGE FOR POSTERITY

If you want to use contemporary images from print media in a collage, you need to photocopy them onto acid-free paper first. The paper used for printing today is generally made from treated wood pulp, and so is not acid free and will deteriorate very quickly. You can use scanned and printed images, but you will want to make sure that the paper and printing ink in your printer is archival. (This goes for making copies of personal photos, too.) Archival inks cost more than standard inks, but are worth the expenditure, as they will not fade when exposed to sunlight.

PAPER DOLLS

Paper dolls aren't just for children. Cutout found figures can be transformed by the addition of alternative clothes and body parts to illustrate a fable or witty satire, or simply to amuse. Really nice, clear figures can be found in fashion magazines; figures from magazines from the forties and fifties can be especially evocative.

Look through your collage materials to find figures that could be transformed into wild paper dolls. Cut around a figure, leaving about an inch all around, and adhere it with glue to a piece of heavyweight printmaking paper. Let dry, then cut out the figure with an X-acto knife. Now you can find new clothes for it—or maybe a new head? Plain text makes interesting clothing, as do flowers from a seed catalog, or marbleizing samples from Chapter 7 of this book.

Collage of found papers and samples from the "Water Printing" and "Gouache Resist" chapters

THEMES

Sometimes the easiest way to assemble materials for a collage is to collect related things. Flip through magazines, seed catalogs, antique papers, and old photographs to find images connected by theme or meaning. The varying textures of the different media make an interesting surface when used together. Possible themes could be fish, cows, flowers, women or men, world leaders, baseball, tools, tractors, farm life, city life, or exotic places. Sometimes the papers you have accumulated will determine what theme you use.

Collage of flowers from an antique seed catalog and a plant print from the section on nature prints

WHAT IS LEFT BEHIND?

Save the paper that is left behind after you have cut out an image. Sometimes the remainder is more interesting than what you cut out, and can be used as an element in another collage, perhaps as a window to another place.

Collage of paper from an antique newspaper and a photograph copied onto acid free paper

PICTURE MATS

You can use the principles of collage to deco-
rate picture-framing mats with collage materi-
als. These mats create an interesting window,
adding new dimension to a simple image or
collage. Use precut mats, or cut your own
using museum board and an X-acto knife.

Picture mat and picture from antique newspapers

Picture mat covered with antique paper, egg from "Water Printing" chapter

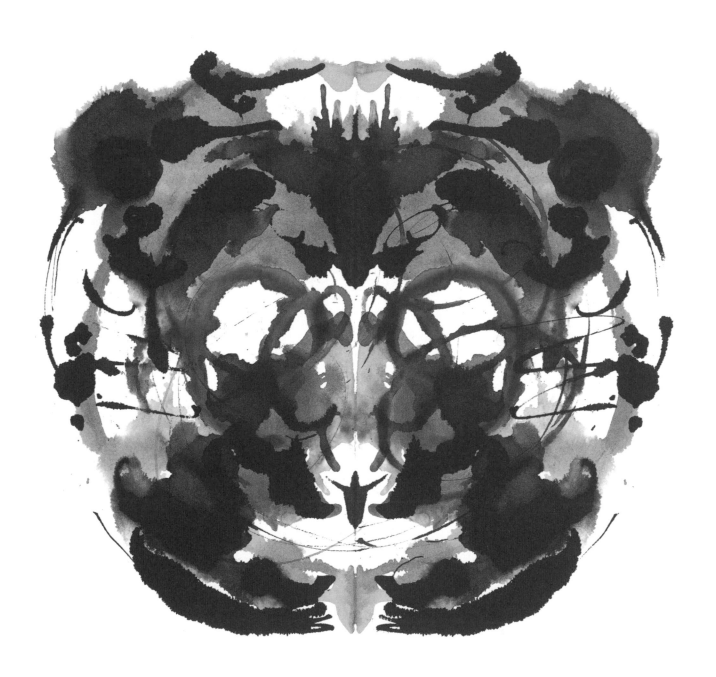

INKBLOTS

Blot ink and water on paper, fold and unfold, and see fabulous creatures, alien beings, and magical landscapes, all within the swirls of ink! An inkblot is formed simply by dabbing ink and water onto a piece of paper, folding the paper in half with the wet ink and water inside, then unfolding the paper. Inkblots differ from each other depending upon how the ink is applied, how much is applied, and how the paper is folded. Because inkblots made in this fashion are somewhat symmetrical, they can suggest to the viewer images from life that are also symmetrical: a face, two figures interacting, a tree with spreading branches and roots, an animal, lovers. Sometimes the inkblot image can be suggestive of something that the viewer has never seen but only imagined: a monster, a crazy plant, a space ship.

Klecksographie, or Blotto, was a children's parlor game from the twenties, where participants looked at inkblots and said what they "looked like." Hermann Rorschach, a psychoanalyst in Vienna in the early 1900s, observed the game and was intrigued by the different answers given by the players. He devised ten different inkblots to use in the analysis of emotional and intellectual operation. This chapter on inkblots will not help you draw any formal conclusion about your psyche that could be divined from making an inkblot; rather, making and looking at the inkblots is a means to getting creative juices flowing, getting out of artist's or writer's block, or accessing new ideas through creative play.

In this chapter, you will explore single- and multiple-fold inkblots, as well as nonsymmetrical inkblots. Inkblots are the subject of the last chapter of exercises in the book because they are an ideal introduction to making the second mark: Perhaps you will be inspired to begin "drawing into" the inkblots you have made to enhance what you see in the silver and black pools of ink.

Opposite
India ink and water on paper folded to make symmetrical image

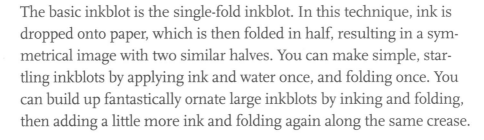

BASIC INKBLOTS

The basic inkblot is the single-fold inkblot. In this technique, ink is dropped onto paper, which is then folded in half, resulting in a symmetrical image with two similar halves. You can make simple, startling inkblots by applying ink and water once, and folding once. You can build up fantastically ornate large inkblots by inking and folding, then adding a little more ink and folding again along the same crease.

below and opposite
India ink and water on paper folded to make symmetrical images

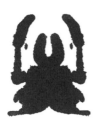

YOU WILL NEED:
protective gloves
waterproof india ink
various applicators (brushes, cotton swabs, toothpicks, eyedroppers)
2 sheets light to medium-weight white or cream-colored printmaking paper, torn into various sizes

Put on the gloves. Apply ink to a piece of paper using your choice of tool. You won't need a lot: just a couple of drops or swirls. Add a drop or two of water. Fold the inked paper in half, pressing the two halves together. Unfold. What do you see? Set aside to dry.

Make more inkblots; it will take time to get the hang of how much ink and water to use. Try folding the paper in half first, before dropping the ink and water on. How does that change the inkblot? Experiment with using more and less water, and also using no water, just ink.

Dab ink, drop ink, splat ink, playing with different applicators. Make puddles and lines and swirls and crisscrosses. Try putting ink right in the middle of the paper before folding. On another, put ink only around the edges of the paper, avoiding the middle. How does this change what you see when you unfold the paper?

Experiment with how you apply pressure to the inked, folded paper. Try pressing straight down with the full flat of your palm. Press lightly. Try another and press heavily. How does this change the image you see when you unfold the paper? On another piece of paper, try applying pressure with one finger moving in a spiral over the folded surface, or with pressure radiating from the fold of the paper. What do you see?

How does it look when the ink goes all the way to the edge of the paper and over? How does the image change when the ink doesn't touch the edge of the paper? If your paper doesn't have enough ink on it for you after the first inking and folding, add another drop and fold it again.

Experiment with scale. Make some tiny inkblots on small pieces of paper. (Use less ink and less water.) Now try larger pieces, say 11 by 15 inches, or even 22 by 15 inches. (Use more ink and more water.) How do the inkblots change as they get bigger and smaller?

Drop ink and water on a large piece of paper. Fold and unfold. What do you see? Now add more ink and water in the bare places. Fold and unfold. Add more ink and water and fold again. You can build up a very complex looking inkblot by this method.

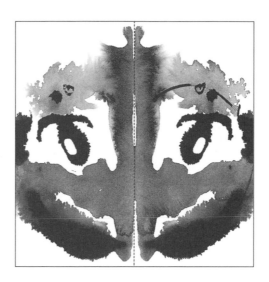

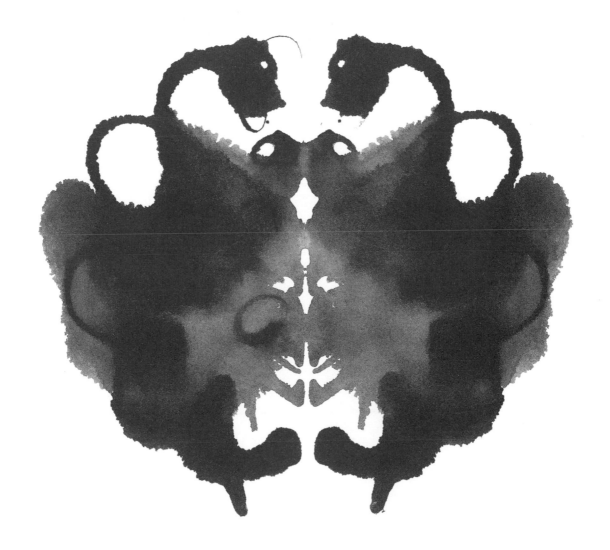

MULTIPLE-FOLD INKBLOTS

opposite
India ink and water on
paper folded four times to make
symmetrical image

below
India ink and water on
paper folded twice to make
symmetrical image

To make multiple-fold inkblots, you should
use a lighter-weight paper, and one that has a
high cotton content so that it folds easily. Now
try putting a couple of drops of ink and water
on a piece of paper, and fold. Unfold and fold
again, perpendicular to the first fold. If your
ink is still wet, fold the same paper again
along another axis. You may have to add more
ink for the third fold, and perhaps even for the
second fold. What do you see? An elaborate
insect? A chandelier?

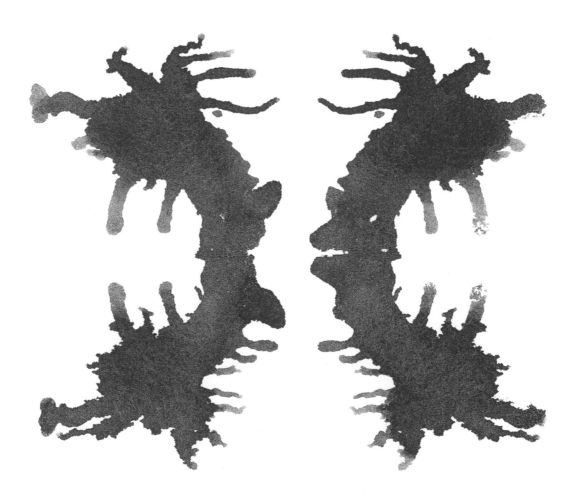

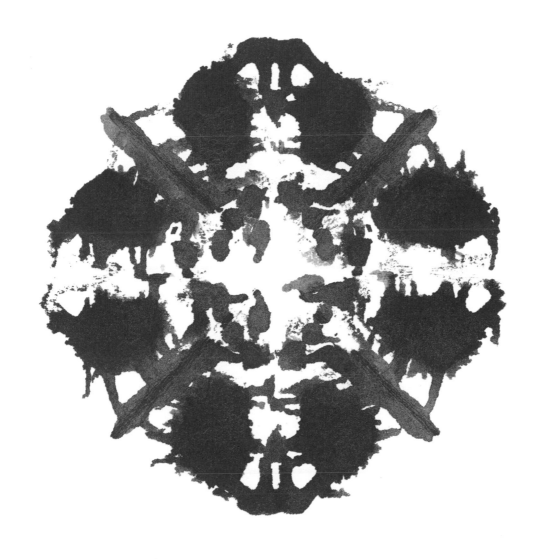

POURED INKBLOTS

opposite
India ink and water pooled and
rolled around on page

Victor Hugo, the French novelist and visual artist, is said to have added differ-
ent substances to his washes and poured-ink images, including coffee, coffee
grounds, and wine. These substances tone the paper, evoking age and history.
In this exercise, we'll borrow Hugo's coffee idea, and also experiment with
salt. Urea crystals or drops of isopropyl alcohol sprinkled on the wet ink and
water will also make interesting marks. This method makes some wonder-
fully intricate marks where the ink pools dry, as well as some broader washes
of dark and light.

YOU WILL NEED:
protective gloves
waterproof india ink
applicators (brushes, cotton swabs, toothpicks,
 eyedroppers)
2 sheets light to medium-weight white or
 cream-colored printmaking paper, torn into
 various sizes
salt
coffee grounds
coffee

Put on the gloves. Apply ink and water to a
piece of paper with your choice of applicator.
Tilt the paper like a waiter balancing a tray,
guiding the inky pools around the page.
Sprinkle salt on the wet pools. Let dry and
shake off the salt. What does the salt do to
the drying ink and water? Make additional
samples using different applicators.

Try putting some coffee grounds and a few
drops of coffee on a piece of paper. Let dry
and shake off the grounds. Try again with
coffee and grounds, adding some ink to it as
well. Let dry and shake off the grounds. What
do you see? Does the color of the coffee sug-
gest other things than the black and grays of
the ink do? What?

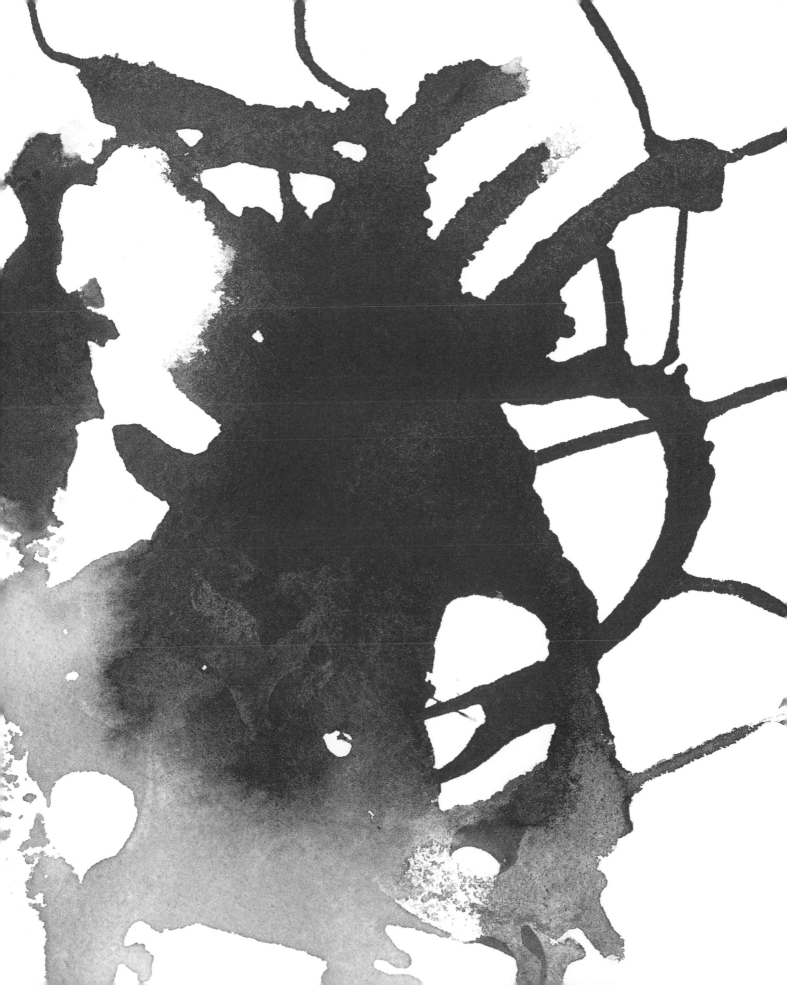

DRAWING INTO YOUR INKBLOTS

When you look at the inkblots you have made, what do you see? Eggs, flowers, bats, rabbits, mice, men, dragons, ropes, eyes, birds, beaks, bulls, monsters, fish, faces, crows, women, babies, angels, cows? Do you see swirling clouds? Landscapes? Seascapes? Grasses, seaweed, planets, stars, black holes? What we see in inkblots differs based upon how we differ from each other. In this section you will find tips on how to look at inkblots, and how to "draw into" the inkblots you have made to enhance what you may see.

YOU WILL NEED:
inkblots from the previous exercises (pages
 142–146)
black acid-free pen (a Pigma Micron pen,
 size .05, is a good option)
white pencil

What you see in your inkblot will differ from what someone else sees in the same blot. Flip through the inkblots you have made. Some recognizable imagery will jump out at you right away, and other inkblots take more patience. An inkblot might have one recognizable image tucked into clouds of black and gray ink, or you may see a lot of things in one blot, or you may see just one giant image.

Look at the inkblots one way, then turn them upside down and look again. Sometimes you will see the same shapes as different images depending on the orientation of the page. Look at the positive marks—the black and gray—and also look at the negative spaces, or white areas, defined by the ink.

The billowing grays and blacks within the shapes can represent a rounded or concave surface, such as the curve of a cheek, or the

recesses of an ear. Look for symmetrical things such as figures fighting or dancing, faces, insects, crabs, spaceships or planes, planets. Don't be surprised if you see odd situations: alligators playing chess, a woman holding a giant chicken. That's part of the fun of looking at an inkblot: Give your imagination the freedom to run wild. Also, you might see interesting abstract shapes, and not a recognizable image at all.

Choose an inkblot in which you "see" something. It is interesting to draw only on one half of the symmetrical inkblot so that you can see where you started. Draw around the perimeter of what you see with the black pen. Add any important internal detail. Use the white pencil to add volume, enhancing the roundedness you may see in the shape. Ignore parts of the inkblot that don't look like anything. You can even color them out with the white pencil. Make stuff up if you want: Add eyes where there are none, for example. After you pull one figure out of an inkblot in this manner, the rest of the inkblot may start to evoke a place, another figure, a conflict or other situation.

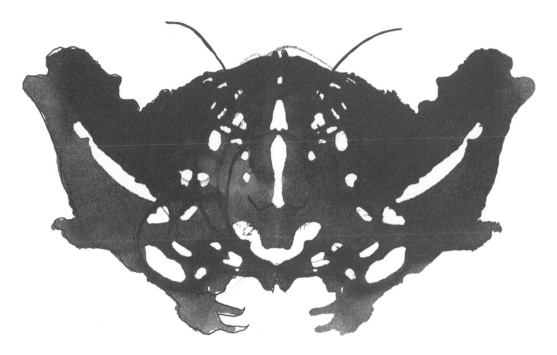

left
India ink and water
on paper folded to make
symmetrical image,
then pen lines added to
describe a figure seen
within the inkblot

below
India ink and water on
paper folded twice to make
symmetrical image,
then pen lines added to
describe figures seen
within the inkblot

WHAT IF YOU DON'T SEE ANYTHING?

If you don't see anything in one inkblot, put it aside and look at another.

Sometimes you will see something in the first one later, but some inkblots never look like anything. You might not see anything in any of your inkblots right away. In that case, pin them up in a place that you pass frequently during the course of the day. Look at them before you go to bed at night to let your subconscious think about them while the rest of you is asleep. Often in the morning, images will begin to reveal themselves.

Be patient!

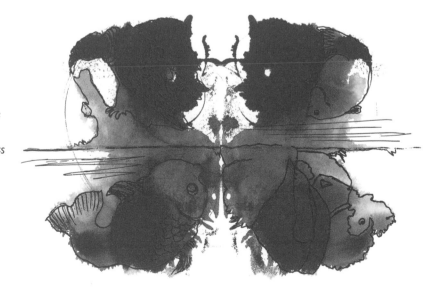

MAKING YOUR NEXT MARK

Now that you have done the exercises in this book, what do you have? The tangible things are a place to work, a stack of completed exercises, and some new art supplies that you know how to use. That's good. The gains that are not physically apparent have happened in your brain and body: You have some new skills, more confidence, a newfound aesthetic sense, and some ideas of what you like to do. You are ready to tackle a new problem, you are poised to continue, thus fortified, along your creative path.

opposite
Sprayed lemon juice and methyl cellulose on paper, dried hydrangea blossom as stencil, baked to reveal image

The skills you have learned have many art-and-craft applications. How can you apply them to best suit you? In this chapter, use the questionnaire to help you zero in on what you want to do with what you know. Additionally, there are thoughts for taking yourself on a fact-finding mission at a museum, suggestions and ideas for art-and-craft projects to get you started, and some drawing tips.

Good luck making your next mark!

FIND YOUR OWN CONTEXT: A QUESTIONNAIRE

To have a successful creative experience, it is sometimes helpful to evaluate who you are and what you like. Plumb your own life experience for ideas that excite and inspire you. The following questions are intended to help you define your own context and to spark thoughts about where you will go next.

Which exercises did you like the best in the book? Why?

Did any of the exercises make you think of a project to which you could apply the skills you learned? If so, what?

Did any of the exercises remind you of something you have done in the past that you liked?

What didn't you like? Why? Were you merely indifferent to that technique or did you absolutely hate it? Why?

What creative things do you do now? Gardening, cooking, writing, interior decorating? How could you further your exploration of the creative activities in which you are already engaged using the techniques in this book?

In museums, where do you go first? What do you like to look at the most there?

What do you know about that could inspire a creative project? At what are you an expert? If your answer is "Computer Technology" or "Euchre" or "Medicine" or "Childcare" or "English Literature" or "Baking," break it down: What specifically are you good at in those occupations? What do you like about what you do?

What have you always wanted to do and never done? Travel, rock climb, ski, learn a language, meet the Queen? How could you explore those things creatively?

What colors do you like? This book has introduced techniques in an austere palette, but you are not limited to this now. What palettes are you drawn to? Do you have a beautiful scarf or sweater that you love for its colors? Do the colors of a particular painting appeal to you? Or autumn leaves? Gray tree trunks and cool winter light? How could you use these colors to their best advantage in an art work?

What objects are you drawn to? Look around your home: What sorts of things do you collect? Books, boxes, bowls? Old magazines, photographs, toys, quilts? Why are you drawn to these objects?

Choose one of the objects from the previous question. If you could make an object that would complement this object, what would it be? A box to put it in? A painted cloth to rest it on?

JUMPSTART: IDEAS

Here are some ideas for things to make and do with what you have learned. Like the find-your-own-context questionnaire (pages 152–153) and the museum walk (page 158), this list is designed to inspire you and get you thinking about what creative project you would like to try. You might not find a specific project here that interests you, but one of these ideas might spark another idea all your own. All of these ideas can be fun, crafty projects, and all can cross the line into art works. Think of the things you saw on your museum walk: Art is not just paintings!

- Many of the techniques in this book lend themselves to use with fabric paints: stencils, roller prints, water prints, nature prints. Make a painted kimono to hang on the wall, or give fish-print T-shirts to everyone on your softball team. Paint scarves, clothing, quilt tops, tablecloths, banners.

- Make your own playing- or tarot-card deck. Buy a deck as a guide, then collage images and stamp decorative borders onto paper. Your cards do not have to be rectangular; they can be round, oval, or square. Photocopy your cards onto card stock, spatter or spray through lace for the backs, and have them laminated.

- Many of the techniques in this book are great for painting on a wall in your home. Use acrylics to make borders, roller print a repeated design or texture, or stencil your bedroom with a wainscoting of cornstalks, so you can wake up every morning in a late-summer field.

- Do you feed birds? Are you starting to be able to tell them apart? How do you differentiate one from the other? Could you make a chart that showed each one and its individual markings? Could you use a stencil for this? Or stamps? Or nature prints of feathers?

- Do you love fabric stores because of the riot of patterns and colors? How could you use cut stencils or lace to represent that riot of patterns? Could you use stamps? Water printing? Roller printing?

- Make a game board. Start from scratch, or use an old game board as a base and collage on top of it. Find game pieces and decorate a box to hold them.

- Do you remember your favorite game to play as a child? What was it? Can you make a pictogram of how it was played? If it was tag, say, could you make a grassy "game board" using a "grass" stencil? What's "Home"? How could you represent that on your board? Can you have game pieces that represent the different players? Would they be "children" or different graphic symbols? Or leaves? Does your game have a box?

- Make a set of stationery: Buy ready-made blank cards and envelopes at an art supply store to embellish. Use stencils, marbling, or paste designs directly on the cards, or mount dyed papers, nature prints, or rubbings on the cards. Make invisible-ink stationery and send it with instructions to the recipient on how to bake it to see the image. Use this stationery to correspond with your friends, or create an imaginary correspondence between two mysterious people.

- Did you ever sit and watch your mother bake a cake? What did her kitchen look like? What ingredients did she use for the cake? How could you represent all those things visually? Make a booklet that shows the ingredients and how they became a cake. If you wanted to make two booklets, one for you and one for your mother, how could you use carved erasers and a stamp pad, or stencils, to help you make more than one book? What other experiences could you describe in this way?

- Make a tabletop theater: Construct a stage set, make paper doll characters, write a play for them. Does your theater need a beautiful box to live in?

- Make a zoo; include inkblot animals and monsters, and paint dioramas behind them.

- Write a botanical journal of a fantastic imaginary place. How could you use the nature prints or acrylic-medium fossils in this book? Maybe it is an old box containing the collected writings and samples from a long-forgotten amateur naturalist.

- Did you ever walk into the cool of a dark barn on a summer afternoon? How did the light look as it peeked through the cracks in the barn walls? What aspect of this experience might you especially want to duplicate? The bright straw on the dark floor? Could you use found-object stencils for this? How? Could you use gouache resist to represent the sun through the slats? How can you show the contrast between the very hot outside and the very cool inside?

- How can you record the changing beauty of your flower garden? Could you use gouache resist or sun-sensitive papers to make a seasonal series to admire through the non-gardening months?

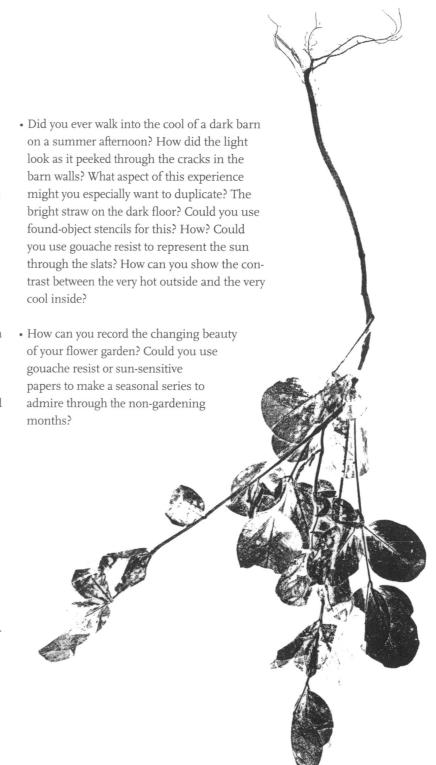

DRAWING

Now that you have had some experience getting things down on paper using the various techniques described in this book, you may be ready to do some drawing. The reason we draw is to represent something that's in our minds, or to respond artistically to something we see. Almost always, the best way to represent something is not photo-realism. For example, if you want to draw a picture of the horse you once rode as a child and the most striking thing about the horse that you recall is how long its legs were and how tall it was, then a photograph, or something drawn so that it looks photographically real, will never do. It is your remembrance of those legs from a child's perspective that you must try to capture, even though there's no horse alive that has legs that long, really.

Find an image you want to draw, in life or a photograph, or respond to what you see in one of the exercises from this book—an inkblot, for example. However you draw, whenever you draw, it is important to stay loose. If you have never drawn before, try the following exercises to begin and to see what approach suits you best. Any of the exercises can also be done with a brush and india ink.

One way of loosening yourself up is as simple as changing the environment in which you usually draw. Do you usually draw sitting in a chair? Then stand up and draw at a table or with your work pinned to a wall. Do you usually draw standing at an easel? Then sit at a table, or better yet, sit on the floor, with your work spread around you, like you were playing with your best friend and she just went to see what her mom wanted, leaving you for a few moments. See what works for you. The point of this is to break, or unlearn, your patterns, or, if you are just starting out, to break your preconceived notions of how to have a creative experience.

Another way to loosen up your drawing hand is to use different drawing muscles. Instead of using your dominant hand, try drawing with your nondominant one. Keep in mind the beautiful drawings kids make that grace the refrigerators of this land when you get frustrated with your results. You are not trying to make yourself ambidextrous or make your nondominant hand as skilled as your dominant one; you are trying to use different drawing muscles and carve new pathways in your brain.

You can use different drawing muscles by taping a pencil or brush to the end of another pencil or brush. Tape your paper to the wall and draw with this implement. Tape a pencil to a long dowel (try a 3-foot-long, ½-inch-thick dowel) in two places, so it won't wiggle. Tape your paper to the floor, stand above it, and draw with this super-long pencil. What muscles are you using now? (Drawing this way is how muralists and scenic artists for the theater work.)

Keeping the above techniques in mind, get out the samples you have made while working through this book. You should have quite a pile of them now! Look through them. What do you see? Is there something missing?

You may now want to indulge the desire to experiment with color. There are so many different media to choose from, each with different qualities, requirements, and application methods to learn. A simple and economical way to begin your exploration of color is to buy some water soluble inks in basic colors such as blue, red, green, and yellow and a couple of brushes to use with them, such as a half-inch flat watercolor brush, and a smaller pointed

brush. These inks often come with an eye-dropper in the bottle. Buy a white plastic palette, or use a clear plastic egg carton in which to mix the inks with each other to make different colors, or with water to lighten them. When you buy inks, be sure to buy inks with good lightfastness, which refers to the propensity of the colors to resist fading when exposed to the sun or other light. The label will say this, but ask a store clerk if you are unsure. Also purchase a small starter set of colored pencils. You can use these to add color to exercises from this book. Try tinting a collage or nature print with the inks, or use colored pencils to pull imagery out of an inkblot. You will learn something about how colors combine and work together as you experiment, and there are also many good books about basic color theory where you can find out more.

MUSEUM WALK

A museum walk is a great way to introduce yourself to what you like. You might be surprised by what you find out. You might go to the museum thinking you really like only Impressionist painting and leave with a burgeoning interest in Chinese ceramics. If there isn't an art museum around, then visit a natural history museum that has artifacts from human life: textiles, dishes, regional costumes, ceremonial objects. If you don't have any museums near you, go to museum sites online, such as the New York City Metropolitan Museum of Art site at www.metmuseum.org. Wherever you go, take along a small pad of paper and a pencil. If you see something that interests you, record it in some way on the pad of paper. The way you record it is up to you; just choose a method that is sure to bring the image to mind vividly when you flip back through your notes. Write what the object is; a detailed description; why you like it; what the color, texture, and size is. Make a quick sketch—stick figures will do— just to jog your memory later. Maybe there is something about the accompanying label text that interests you; write this down.

Move through the museum somewhat quickly, taking in as much as you can, as if you were turning through a cookbook without actually making any of the recipes. Try to be disciplined about this; you can come back to things that interest you at the end of your walk.

Don't limit yourself to the paintings. Look at pottery, armor, textiles, religious artifacts, sculpture, jewelry, prints, books and manuscripts, photography, the decorative arts. Look at objects from cultures different from your own: Pacific Northwest Coast Indian art, Asian art and objects, Egyptian artifacts, African masks, Persian miniatures. Look at objects from civilizations that don't exist anymore: Pompeiian or Cycladic art. Look at things you didn't think would interest you from their name on the museum floor plan.

At the end of your walk, sit down and look through your notebook. How do your notes reveal what you like? What similarities do you see between the things that moved or interested you? Are there similarities in theme, structure, color, texture? Did you see anything you would like to make? A suit of armor, a book, a necklace, a traveling altar, a piece of painted pottery, a mural? Save this notebook and take it on any art- or craft-looking outing. Record what you see. You will find this a useful tool for inspiring ideas for things to make and do.

If you are at an actual museum, and not a virtual one, take yourself to the giftshop to look at postcards. If you don't already have a place where you pin up postcards you like and respond to, now is the time to start your miniature gallery of images.

AFTERWORD

Hopefully, this book has helped you make some marks on paper that you're pleased with. What have you responded to? What did you love? What did you hate? Do more of both those things—the things that are "hot" for you. If you tried an experiment that left you indifferent, leave that avenue for now; you can always pick it up later. Be true to yourself. Do work you care about. Try new things, and don't be afraid to try experiments that might not pan out. That is the essence of making art of any sort. You have some tools in your toolbox and some ideas in your head: You are on a wonderful journey.

Bon voyage!

STENCIL PATTERNS

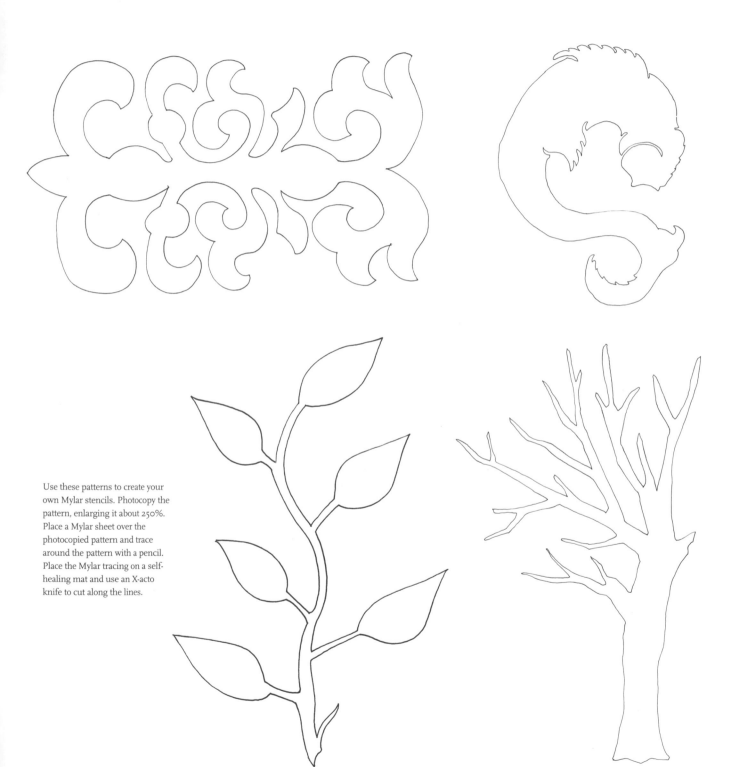

Use these patterns to create your own Mylar stencils. Photocopy the pattern, enlarging it about 250%. Place a Mylar sheet over the photocopied pattern and trace around the pattern with a pencil. Place the Mylar tracing on a self-healing mat and use an X-acto knife to cut along the lines.

SUPPLIERS

You can obtain most of the supplies for the exercises in this book at any art supply store. Materials that are harder to find are specified here with their supplier.

A.I. Friedman
Multiple locations in New York
(800) 204-6352
www.aifriedman.com
Art supplies.

Acorn Naturalists
155 El Camino Real
Tustin, CA 92780
(800) 422-8886
www.acornnaturalists.com
Resources for classrooms, including fish replicas for gyotaku. Online catalog.

Amsterdam Art
1013 University Avenue
Berkeley, CA 94710
www.amsterdamart.com
Art supplies.

The Art Store
Multiple locations in the United States
(888) 5-GO-ARTS
www.artstore.com
Art supplies.

B&H Photo-Video-Pro Audio
420 Ninth Avenue
New York, NY 10001
(212) 444-6615
www.bhphotovideo.com
Kodak Photo-Flo 200, catalog.

Daniel Smith Fine Artists' Materials
P.O. Box 84268
Seattle, WA 98124-5568
(800) 426-6740
www.danielsmith.net
Art supplies. Catalog.

Dick Blick Art Materials
P.O. Box 1267
Galesburg, IL 61402-1267
(800) 828-4548
www.dickblick.com
Art supplies, sun-sensitive paper. Catalog.

Eckersley's
Nine stores within Australia
(1300) 657-766
www.eckersleys.com.au
Fine art supplies. Catalog.

Flax Art and Design
Multiple locations in California
(800) 343-FLAX
www.flaxart.com
Art supplies.

Holloway Art & Stationers
222 Holloway Road
London, England
0207 607 4738
General arts and crafts supplies, and mail-order catalog.

Lab Safety Supply
(800) 356-0783
www.labsafety.com
Safety supplies: nitrile (non-latex) and latex gloves, respirators. They also carry rubber mats to relieve the strain of standing on concrete. These might be useful to you if your studio space is on a concrete or tile floor. Catalog.

Michael's Arts and Crafts
Multiple locations in the United States
(800) 642-4235
www.michaels.com
Arts and crafts supplies.

New York Central Art Supply
62 Third Avenue
New York, NY 10003
(800) 950-6111
www.nycentral.com
Over 3,000 papers, including handmade, mould-made, decorative, and rolls; Preval spray guns and spray diffusers; PVA; bone folders. Catalog.

Opus Productions and Art Gallery
300 West Hastings
Vancouver, BC
V6B 1K7
(604) 687-4093
Art supplies.

Pearl Paint
Multiple locations nationwide
(800) 221-6845
www.pearlpaint.com
Art supplies, including Rich Art paints, Createx dyes and paints, and Preval spray guns. Catalog.

PhotoOptix
73 Praed Street
London, England W2
0170 889 0723
www.photooptix.co.uk
Photography supplies.

Rose Brand
(800) 223-1624
www.rosebrand.com
Theatrical supplies, cheesecloth and erosion cloth, chip brushes in bulk (much cheaper than the hardware store).

Talas
568 Broadway
New York, NY 10012
(212) 219-0770
www.talas-nyc.com
Bookbinding supplies, specialty tools, paper, bone folders, methyl cellulose, wheat and rice starches, PVA, X-acto knives, scalpels. Online catalog.

University Art
Multiple locations in California
(800) 736-3501
www.universityart.com
Art supplies.

GLOSSARY

acetate A clear, plastic-like material available in either sheets or rolls of various thicknesses; good for overlays and drawing when labeled "prepared."

acrylic gel medium A whitish, liquid substance that dries clear, typically mixed with acrylic paint to change the texture of the paint or to make it more transparent on the canvas. The medium can also be used as a varnish over the surface of a painting to change the surface quality from matte to gloss. Just like acrylic paint, acrylic gel is soluble in water when wet and becomes impervious to water when dry.

atomizer A folding device consisting of two metal tubes joined in the middle at an acute angle. One tube end is immersed in a liquid and the other, often tipped with a plastic mouthpiece, is blown into to spray the liquid diffusely. An atomizer is commonly used to spray non-aerosol fixatives, or certain artists' varnishes, directly from bottles and jars. It is sometimes called a spray diffuser.

block-printing ink *see* relief-printing ink

bone folder Small, flat picket- or ruler-shaped tool about an inch wide and of various lengths; the classic length is 6 inches. Made of plastic or genuine bone with one edge slightly sharper than the other, it is used to make exact creases when folding paper.

brayer A hard rubber roller with a handle, used to apply ink to a relief-printing block.

bridge A connective tab that hold parts of a stencil together. For example, if you want to make a stencil of the uppercase letter R, you must leave 1 or 2 bridges somewhere around the curved part of the R to hold in the center.

chip brush Wooden-handled, natural-bristled, inexpensive, readily available brushes made for applying paste, glues, etc.

chop mark A distinctive mark placed on a work with an inked or uninked stamp to show ownership or authorship, or to validate an original work.

ebru A traditional marbling technique developed in Turkey in which a medium that doesn't mix with water, such as oil-based paint or ink, is thinned with oil or turpentine, then dropped into a shallow tray filled with water. The oil color floats on the surface of the water. Sometimes the water is thickened slightly to aid the flotation of the pigment. In Europe, the paper to be marbled by the *ebru* method was first soaked in water and aluminum sulfate, or alum, and dried before laying it on the water to absorb the swirls of oil color.

gouache A water-based opaque paint. It is made from ground pigments bound in gum arabic, a secretion of many trees and plants that hardens when it dries but remains soluble in water.

gyotaku The Japanese art of making a print from a fish (*gyo* means "fish" and *taku* means "rubbing").

india ink A black, free-flowing ink used for drawing, painting, and quill and technical pens. It is available in either waterproof or water-soluble forms, and is noted for its deep warm tone.

kraft paper A coarse, unbleached paper noted for its strength, most familiar to us in its grocery bag and packaging paper forms.

marbling The art of swirling pigmented media on the surface of water and lifting an impression of the swirls with a piece of paper. Also called water printing.

methyl cellulose A weak adhesive commonly used for bookbinding, paper making and repair, and wallpapering. It can also be used as a thickener. Matte when dry. Comes in a powder form and must be mixed with cool water prior to use.

Mylar A plastic-like material available in various thicknesses, clear or matte, and in sheets or rolls. It is used for overlays, or, when labeled "prepared," for drawing, and is ideal for stencil cutouts as it is flexible and doesn't become brittle with age and use.

plastic cutter A mat-knife-like tool for cutting plastic, acrylic, and other sheet materials. The sharp tip is used to create an initial score line, then more pressure is applied with subsequent passes of the cutter until the material is scored through or will break easily along the score line.

polyvinyl acetate A synthetic glue, commonly called PVA.

Preval spray gun A pocket-sized paint sprayer consisting of a glass bottle to hold paint and a small, screw-on canister of compressed air.

relief-printing ink Ink for use with relief-printmaking blocks. Stiff and sticky in consistency, it can be found in both water and oil-based forms. Same as block-printing ink.

resist A substance that is applied to a surface to prevent another medium from soaking in or adhering to that surface. An example of a resist is wax as it is used in batik: the design is rendered in wax, which blocks dye from the area of the design while the rest of the fabric is penetrated.

rocker A wood-graining tool used by decorative painters to make bold, simulated wood-grain patterns in paint. The surface of the tool has concentric half-circle ridges, and it is rocked back and forth to make the wood-grain pattern.

self-healing cutting mat A plastic-like mat that has a special surface and core that work together to magically return to smoothness after cutting, protecting your work surface and knife blades from damage.

shibori The Japanese art of pattern dyeing.

silicone tile adhesive A quick-drying, rubbery substance that comes in a tube with a pointed tip out of which you extrude the adhesive.

stencil Anything that blocks paint from part of a surface during painting. Masking tape or a cutout plastic or oil-paper border are examples of stencils.

stencil burner A stencil burner is an electric tool used for "cutting" plastic stencils with heat. It looks a little like a soldering iron, with a wooden handle and a copper tip that heats up to melt the stencil plastic.

sumi ink A carbon-based ink available in stick form, which you grind and mix with water, or in premixed aqueous form.

suminagashi The first known form of marbling is the centuries-old Japanese method called *suminagashi*. In *suminagashi*, a monk would sit beside a pool of water, and when the pool was absolutely still, he would drop sumi ink onto the surface of the water. The water had to be perfectly calm so that the surface tension of the water would prevent the ink from sinking. The monk would fan the water or blow at the ink through a reed to create swirls in the surface of the ink, then lay a piece of paper on the water to lift the ink off.

value Lightness or darkness. For example, white is a light value, and black is a dark value.

value pattern The movement of lights and darks across a page in an artwork or design.

water printing *see* marbling

INDEX